IMAGES
of America

PRINCETON
UNIVERSITY
THE FIRST 275 YEARS

DINING TOGETHER. Princeton prides itself on being small and intimate enough to be a community. For half a century, virtually every freshman and sophomore made this trip three times a day to dine in the Commons (now Madison Hall). When the Commons was completed in 1917, for the first time since the College of New Jersey's early days, whole classes could dine together. Diners approached the five dramatic Gothic halls through the monastery-style Holder Cloister, a copy of the 1390 cloister at New College, Oxford. (Princeton University Archive.)

ON THE COVER: PRINCETON UNIVERSITY CHAPEL. These students are walking by the world's third-largest collegiate chapel. In recent decades, it has been the place of worship for a variety of religions and the scene of major interfaith events ranging from the welcome of freshmen to the graduation baccalaureate to the annual memorial service. Few know that it was built to revive Princeton's 200-year Presbyterian tradition. (Princeton University Archive.)

IMAGES
of America

PRINCETON
UNIVERSITY
THE FIRST 275 YEARS

W. Bruce Leslie

ARCADIA
PUBLISHING

Copyright © 2022 by W. Bruce Leslie
ISBN 978-1-4671-0735-8

Published by Arcadia Publishing
Charleston, South Carolina

Printed in the United States of America

Library of Congress Control Number: 2021949907

For all general information, please contact Arcadia Publishing:
Telephone 843-853-2070
Fax 843-853-0044
E-mail sales@arcadiapublishing.com
For customer service and orders:
Toll-Free 1-888-313-2665

Visit us on the Internet at www.arcadiapublishing.com

ENTERING THE TIGER'S (B)LAIR. Blair Hall was designed in 1896, the year Princeton became a university in name and adopted collegiate Gothic as its official architecture, attaching itself to the prestige of Oxford, Cambridge, and other European universities. Donated by longtime trustee and Scottish Presbyterian John I. Blair, the dormitory's dramatic design inspired the adoption of collegiate Gothic on campuses across the country. For many students and visitors, Blair Hall was their first vision of the university as the railroad deposited them below its exhausting stairs and imposing arch. (Princeton University Archive.)

CONTENTS

ACKNOWLEDGMENTS

If I have not stood on the shoulders of giants to compose this volume, I am certainly deeply indebted to a number of gifted historians of higher education. Princeton University has been fortunate to have received an exceptional amount of historical attention; the bibliography samples the riches. I particularly relied on books by James Axtell, Roger Geiger, Alexander Leitch, Barksdale Maynard, Dan Oberdorfer, Richard D. Smith, and Thomas Wertenbaker.

Imagery guides pictorial histories and finding historical images depends upon archives, the engine rooms of history. This book literally would not have come to fruition without the Princeton University archivist, Dan Linke. He always responded cheerfully and helpfully to my endless questions and enabled me to be the first post-COVID visitor to return to Mudd Archive. Additionally, I owe a debt to his ever-welcoming staff, especially to Brianna Garden, who scanned my long list of photographs with remarkable accuracy.

As Arcadia Publishing's format precludes footnotes, I want to note several of Princeton's collections. During the COVID-enforced closure of the archives, the digitized collection of more than 6,000 images in the Historical Photograph Collection, Grounds and Buildings Series (AC 111), was invaluable. So was the Historical Photograph Collection Individuals Series (AC 067). The many images from the Princeton University Archives are indicated by (PUA) in this book's courtesy lines. Begin searches at findingaids.princeton.edu/repositories/univarchives.

The Historical Society of Princeton is another invaluable resource, with its carefully annotated photographic collection located at princeton.pastperfectonline.com/photo. I am indebted to the society's director Izzy Kasdin for granting me access and to her excellent staff, especially Stephanie Schwartz. The society's photographs are indicated by (HSP).

I have mined other archives during the COVID closures thanks to the wonders of the Internet. The abbreviations in the courtesy lines are as follows: Princeton University Art Museum (PUAM), National Portrait Gallery (NPG), Wikimedia Commons and Wikipedia (WM), Digital Public Library of America (DPL), and New Brunswick Free Public Library (NBPL). My personal photographs are indicated by (WBL). Others who provided images are cited by full name.

Many individuals contributed in ways too varied to detail. Among them are Arthur Eschenlauer ('56), Jean Hendry (*80), Gregg Lange ('70), Robert Leslie, James Parmentier ('66), Tom Swift ('76), Kate Vreeland, John Wiener ('66), and John Wriedt ('85). They all have my gratitude.

Finally, Caroline Anderson Vickerson has been a wonderful editor to work with at Arcadia Publishing.

INTRODUCTION

In May 1747, students entered Rev. Jonathan Dickinson's study, breathing life into the recently chartered College of New Jersey. Surely, this small band of pioneers never could have imagined that they were the launching a university destined to become one of the most prestigious in the world.

How did we get from that inauspicious morning to modern Princeton? This volume takes you on a brief tour of those 275 years. But to understand what drew the students to Dickinson's manse on that spring morning, we must reach back even further. Why did a handful of Presbyterian ministers pursue the audacious dream of founding an institution of higher learning at a small crossroads in an 18th-century British colony? Why did students appear at Reverend Dickinson's doorstep? Where did the idea of a college come from?

If founding the College of New Jersey was a very New World act of optimism, it also embraced long-standing cultural and institutional traditions. Yes, we must make the proverbial return to classical Greece, the scholars of which began an intellectual quest that launched the Western intellectual tradition. Homer's *Iliad* and the *Odyssey* recounted a martial society—Achilles did not seek a liberal education! But by the 5th century, relative stability freed an intellectual elite to examine life with perspective. Some, such as those gathered in Hippocrates's school of medicine, specialized. Others, notably Socrates and the Sophists, ranged more widely. Socrates paid the ultimate price for his belief that the unexamined life was not worth living, though the teaching technique bearing his name lives on over two millennia later.

Plato, Socrates's most famous protégé, gave the search for knowledge an enduring institutional form. His academy among olive trees outside Athens lasted for nearly a millennium and bequeathed the term "groves of academe," idealized in Raphael's beguiling image of the scholars strolling under Greek arches lost in thought.

Whereas Plato's Academy offered brilliant dialectical training, it added little knowledge. Plato's most famous student, Aristotle, added empirical research to philosophical debate. His extensive collections of manuscripts and maps as well as natural specimens, inspired new branches of learning while philosophy retained a place as Aristotle wrestled with the nature of knowledge. Aristotelian ideas shaped curricular debate long after English settlers crossed the Atlantic.

Although Greece had been reduced to a Roman province in 146 BC, in Horace's words, "Captive Greece by the charm of her civilization took captive her conqueror." Greek was the language of refinement, and Athens remained a seat of learning until Justinian closed its schools, including Plato's Academy, around 520 AD. The Romans organized Greek pedagogy into the *trivium* and *quadrivium*. The *trivium* reflected Roman emphasis on oratorical skill through grammar, dialectic, and rhetoric. The *quadrivium* contained the scientific fields of arithmetic, geometry, astronomy, and music (as a branch of mathematics). These seven liberal arts and sciences provided the base for training in the learned professions of law and medicine.

Thus, Greco-Roman culture bequeathed a body of knowledge and an enduring curricular model based upon the seven liberal arts and sciences. However, an institutional structure for higher learning did not emerge until a half millennium later, after the vicissitudes of the Middle Ages.

In Western Europe, classical scholarship barely survived in monastic scriptoriums, with little knowledge of classical science and mathematics. Most scholarly advances were in the Islamic world, especially Andalusian Spain. Then, despite entering the second millennium as a backwater, Western Europe stabilized and prospered. Emerging nation-states in creative tension with the Catholic Church provided the conditions for the rise of the West. Increasing contact with the Arab world reconnected Europeans to Greek scholarship and several centuries of Islamic scholarship.

This rebirth led to the institutionalization of intellectual life. Bologna, often cited as the first university, dates from 1088. Leading legal scholars had attracted students into a *studium generale*.

Conflicts with the church and local authorities led to its formal recognition as an academic guild, bestowing protections and privileges upon students and scholars. An important precedent had been established. As advanced learning gained stature, a body of law developed for the academic guild, or universitas.

How did the path to Princeton cross the Alps and, ultimately, the English Channel? As the concept of the university moved north, variants emerged, most importantly in Paris. By the early 1100s, a *studium generale* had formed along the Seine, with students especially drawn by the charismatic and controversial Abelard. His *Sic et Non* displeased the church, and his star-crossed love affair with his pupil Heloise led to monastic banishment.

To avoid future Abelards, the church placed the *studium generale* under the looming authority of the chancellor of Notre Dame. Unlike at Italian universities, students exerted less power than the scholar's guild, which established control over granting degrees codified in graduations and echoed in today's rites. By formally making the arts and science degree preparatory for professional degrees, the curriculum evolved in ways that still shape higher education in the United States. The traditions of Roman law and medieval guilds converged to shape higher learning's institutional traditions.

The story continues with England's King Henry II famously falling out with the archbishop of Canterbury, Thomas a Becket, who prudently fled to Paris. In retaliation, in 1167, Henry ordered English students in Paris to return home. Soon, a thriving *studium generale* emerged along a tributary of the Thames. Despite the unlikely location, Oxford grew with remarkable rapidity and, by 1200, bulged with English and foreign students and teachers as well as the requisite booksellers and parchment-makers.

Oxford's transformation from *studium generale* to privileged formal institution followed the continental pattern of town-gown and monarchical-papal disputes. Legendary "Bad King John," foe of Robin Hood and reluctant signatory of the Magna Carta at Runnymede, was locked in a losing battle with the church. Pope Innocent III excommunicated John in 1209, the same year an Oxford student's stray arrow killed a young woman. In revenge, the townspeople hung three students, and the *studium generale* dispersed. King John sided with the town. But when Pope Innocent III brought John to heel, the town of Oxford had to make peace with the church by reducing students' rents and ceding control over the price of food and ale to university officials. The first legal recognition of a university in the Anglophonic world stemmed not from intellectual creativity but from tragedy, revenge, and a power struggle.

Cambridge University traces its origins to the same incident. Many of those fleeing Oxford settled in the fenlands of Cambridgeshire. It was an unlikely location—the town had only a modest reputation for learning and a poor one for health. Some of the emigrants soon returned to Oxford, but enough stayed by the River Cam to generate a second English university, jointly dubbed Oxbridge.

Unlike most continental universities, neither English university resided in a cathedral city. Oxford was far from its bishop in Lincoln, and Cambridge was similarly distant from the bishop of Ely. In this vacuum, the universities elected their own chancellors and sidestepped church intervention until John Wycliffe's apostasy in the late 1300s. By then, both had strong traditions of autonomy.

The Oxbridge town-gown relationship differed from those at most continental universities. The authorities and citizens of cities like Paris possessed the physical and political muscle to challenge the masters and students. Although the citizens of Oxford and Cambridge often took umbrage at the legal privileges and occasionally offensive behavior of students and faculty, power was balanced differently in England. In successive confrontations, the universities emerged with bloodied noses and enhanced privileges.

In the centuries between the foundings of Oxbridge and Harvard, the English universities developed unique patterns of living, teaching, and learning that were carried to the colonies. Particularly important for the colonial colleges was Oxbridge's collegiate residential tradition.

Colleges extended their influence over the next three centuries. Endowments from nobility and the monarchy strengthened the colleges that became the locus of teaching. The Tudors particularly valued the universities as vehicles of statecraft and promoted colleges. Today's tourists visiting

Kings College Chapel at Cambridge or listening to its Christmas Eve carol service benefit from one of the Tudors' most visible and mellifluous legacies.

The English Reformation completed the rise of the colleges. After the dissolution of the monasteries, new colleges literally rose from their ruins, while existing colleges appropriated their endowments, libraries, and even lead roofs. Teaching shifted from university lectures to individual meetings with college tutors, who were personally responsible for undergraduates' intellectual and social lives. Closer control of student lives satisfied Tudor desires for order as well as emerging Puritan moral sensibilities. The colleges became virtually self-contained teaching entities, while university lectures became peripheral. The universities only retained control over examinations and granting degrees. The residential college matured before Elizabeth's death, providing a model carried to the colonies.

For its first three centuries, Oxbridge's curricula reflected continental intellectual life. Then, the English Reformation deflected the intellectual trajectory. Most Catholic authors were proscribed, leapfrogging curricula back to a purer classical tradition. Henry VIII's 1535 Royal Injunctions commanded that all colleges provide daily lectures in Greek and Latin, leading with Aristotle. Once the commentaries were revised to fit post-Reformation sensibilities, the undergraduate curriculum returned to its classical base—another Tudor practice transplanted across the Atlantic.

Under the Stuarts, religious conflicts divided the universities and inspired the migration that carried the English university tradition from old to New England. The universities, especially Cambridge colleges under Puritan control, received unwelcome attention from the infamous Archbishop Laud. Those colleges particularly rejected Anglican practice by hiring married faculty but embraced Cambridge's tutorial system, requiring that tutors assiduously oversee students' moral and religious lives while delivering heavy doses of the classics.

Among Puritans fleeing Stuart oppression were graduates of the Puritan colleges who would transplant academic seeds that had developed over two millennia in their new world. Massachusetts Bay was, arguably, the most highly educated society in the world. Over one percent of the 1630s migrants had experienced university, and preserving that intellectual tradition drove the leaders to found Harvard College barely after the colonists had arrived.

Harvard's charter stipulated that it be *pro modo Academiarum in Anglia* (i.e., according to the manner of universities in England). More specifically, the founders copied Cambridge's Puritan colleges, especially John Harvard's alma mater Emmanuel. They consciously echoed Oxbridge collegiate life, erecting a substantial building containing a dining hall with high table for faculty, a library, and sleeping quarters with studies. The curriculum also closely resembled Cambridge's Puritan colleges, steeping classical learning within a disciplined and pious atmosphere. Latin was the *lingua franca* except in Greek and Hebrew classes. Undergraduate years were devoted to liberal education and training to be Christian gentlemen. For those heading for the pulpit, theological training came later.

Despite deliberate imitation, the English model mutated when transplanted to American soil. Financial need forced innovation. Since these new colleges lacked Oxbridge's endowments, a mixture of public subsidies and private contributions kept them afloat. Oxbridge's level of self-governance was also not replicated. Harvard's board of overseers had founded the college, establishing the precedent of external governance. The Oxbridge pattern of multiple colleges within a university was obviated by colonial dynamics. Anglicans organized the College of William and Mary in Virginia, and Calvinists dissatisfied with Harvard created Yale College in Connecticut.

Thus, the first three colleges acted in concert with their respective colonies' established churches, were monopolies, and received taxpayer support. But in the 1740s, a fourth colonial college was founded in New Jersey that, while sharing the commitment to classical curriculum and collegiate life, would pioneer new models of finance and control that would shape the unique higher education system of the United States.

THE LIBERAL ARTS AND SCIENCE TRADITION. In Raphael's *School of Athens*, Plato and Aristotle stroll through the "groves of academe" past the greatest philosophers, mathematicians, and scientists of classical and Islamic thought. This has become the iconic vision of the liberal arts and sciences that has been at the core of Princeton's mission for 275 years. As the school's charter states, "Youth may be instructed in the learned languages, and in the liberal Arts and Sciences." (WM.)

AND CHARACTER TOO. The second strand of Princeton's founding was inspired by the emergence of evangelical Presbyterianism stressing the conversion experience over doctrinal knowledge. George Whitefield's tours through the colonies in the early 1740s attracted vast crowds and audaciously challenged the more intellectually oriented Calvinism holding sway at Yale and Harvard. George Whitefield was such a powerful speaker that Benjamin Franklin measured the range of his voice. (NPG.)

One

Founding a College in New Jersey

The founding of Princeton reflected the European Protestant Reformation playing out in the colonies and resulting in uniquely American religious and educational solutions. As Calvinists fleeing Stuart oppression had founded Harvard, by the beginning of the 18th century, ideological divisions had spurred another exodus to New Haven, Connecticut. Yale College thrived, but soon it too was divided by controversy that led to another new school.

Several forces intersected and led to the creation of a college in New Jersey, located in Princeton. The first was the Great Awakening that divided the Calvinists who dominated New England and were a major presence in the more religiously diverse Middle Colonies. George Whitefield's revivals in the early 1740s split them into traditional Old Lights and evangelical New Lights. The latter soon decided that they could not depend on the New England colleges to train their ministers, and there was no alternative between New Haven and Williamsburg, Virginia (home of the third colonial college, the Anglican William and Mary).

Their initiative intersected with another strand—Scotch-Irish Presbyterianism, best represented by the Log College. Edinburgh-educated William Tennent had been training evangelical-leaning ministers since 1727, but when the college closed, his acolytes determined they needed a true college and joined forces with the recently chartered College of New Jersey.

Meanwhile, a new colonial governor, Jonathan Beecher, revised the charter in ways that distinguished the college from its three predecessors. Recognizing the colony's religious diversity, he insisted that the trustees include representatives from other denominations and the colonial government. Unlike the first three colonial colleges, the College of New Jersey lacked the support of an established church or of the colonial government. On the other hand, it could appeal to other denominations for funding and students.

A founding trustee, Rev. Jonathan Dickinson, was elected president, and in May 1747, classes convened in his parsonage in Elizabeth, New Jersey. But when he passed away less than five months later, the students moved to Newark under a new president, Aaron Burr Sr. After this wobbly start, the search began for a permanent home and the necessary funding for the college. Appeals to Calvinists—especially the Scotch-Irish—throughout the colonies and in England, Scotland, and Ulster met with considerable success.

Next came the selection of a site that would be mutually agreeable to the New York and Philadelphia synods. Princeton made the best offer, and soon its residents could marvel at the largest building in the colonies rising in their village. In November 1756, Nassau Hall opened.

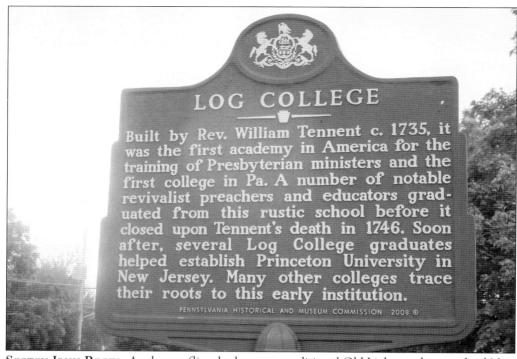

LOG COLLEGE

Built by Rev. William Tennent c. 1735, it was the first academy in America for the training of Presbyterian ministers and the first college in Pa. A number of notable revivalist preachers and educators graduated from this rustic school before it closed upon Tennent's death in 1746. Soon after, several Log College graduates helped establish Princeton University in New Jersey. Many other colleges trace their roots to this early institution.

PENNSYLVANIA HISTORICAL AND MUSEUM COMMISSION 2008 ®

SCOTCH-IRISH ROOTS. As the conflict the between traditional Old Lights and evangelical New Lights simmered, Edinburgh-educated Rev. William Tennent began training ministers. By 1735, he had erected a log college in eastern Pennsylvania and was training a significant number of New Light ministers, though without conferring degrees. His venture followed the Scotch-Irish practice in Ulster in which Presbyterians opened non-degree-granting academies because only Anglicans at Trinity College in Dublin could receive degrees in Ireland. Old Lights derided his school as the Log College, implying that it was academically inadequate. Thus, when Tennent retired in 1745, his sons and acolytes decided they needed a true college. Two years later, they found allies with a college charter in hand. (Above, WBL; below, Thomas Murphy, *The Presbytery of the Log College.*)

"The Original Log College Building," frontispiece from Thomas Murphy, *The Presbytery of the Log College or, The Cradle of the Presbyterian Church in America* (Philadelphia: Presbyterian Board of Publication and Sabbath-School Work, 1889).

A College Is Born. Yale president Thomas Clap's dismissal of a pious New Light student alienated leading ministerial alumni, including Jonathan Edwards, the leading theologian of the day. Consequently, seven New Light ministers and laymen, six Yale alumni, and one Harvard alumnus decided the only alternative was to establish another college. They convinced the governor of New Jersey to sign a charter on October 22, 1746, with the seven men listed as the trustees and headed by Rev. Jonathan Dickinson (right), who was elected president. The next year, they expanded the board of trustees to include two Tennents and three other Log College products. The Tennent brothers, Gilbert and William, vigorously supported the college from their base in the austere and striking Old Tennent Church in Manalapan, New Jersey (below). As allies, the chartered founders and the Log College contingent created a strong base of support among Calvinists in the Middle Colonies. (Right, Presbyterian Historical Society; below, WBL.)

A New Model College. Deservedly the recipient of the college's first honorary degree, Gov. Jonathan Belcher played a critical role in reshaping its original conception and providing stability. A Massachusetts-born Congregationalist, Belcher supported the Calvinist founders and was committed to the success of the College of New Jersey. He astutely realized that the religious diversity of New Jersey meant that the college faced powerful enemies and needed a broader base. Arriving in 1747, he revised the charter, adding representatives from other denominations and colonial officials to the board of trustees. While this reduced sectarian opposition, the colony's religious divisions led to a lack of the public aid that the first three colonial colleges received from their governments. Belcher's steady support was essential in the college's early insecure years. Pres. Jonathan Dickinson died only five months after starting classes in his Elizabeth rectory. The students then packed up and moved to Newark, where Rev. Aaron Burr Sr. took up the presidency, assumed the teaching duties, and began the search for a permanent home for the college. (PUAM.)

A College Comes to Princeton. Given the contending interests of the synods in New York City and Philadelphia, the College of New Jersey needed to be accessible to both. Thus, two mid-Jersey stagecoach stops emerged as contenders: New Brunswick and Princeton. Princeton made the best offer. As generous as local sources were, support from abroad—especially from Calvinists in England, Scotland, and Ulster—was essential in fulfilling the hopes of the locals. In 1753, Rev. Gilbert Tennent (right), trained by his father, William, in the Log College, and Rev. Samuel Davies (below), future president of the college, set sail for Britain. They succeeded beyond their dreams. With word of their success, planning for a college building and a president's house in Princeton could proceed. In 1766, New Brunswick attracted the Dutch Reformed institution destined to become Rutgers University, making New Jersey the only colony with competing colleges. (Both, PUAM.)

AULA NASSOVICA. 1760.

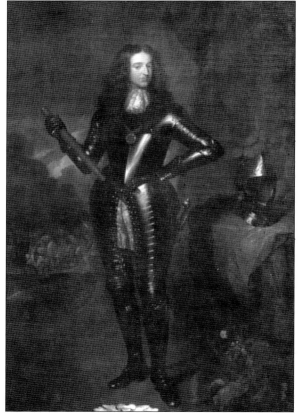

NASSAU HALL. Built of sandstone quarried south of campus, Nassau Hall rose three stories above a basement and was 177 feet across with 94 windows in the front alone. The front entrance led into a prayer hall (today's Faculty Room), with classrooms along the side. Its organ, the first in colonial Presbyterian services, stretched Calvinists aesthetic tastes. Students lived in doubles, and the numerous windows gave each student his own naturally lighted study, a monastic functionality inspired by medieval Oxford. The 1760 sketch is the earliest known image of the college. In gratitude for Gov. Jonathan Belcher's service to the college, the trustees offered to name it after him. He modestly declined (to the everlasting gratitude of generations of Princetonians), instead recommending it be named for the Dutch Protestant hero William of the House of Orange-Nassau, who had ascended the British throne with his wife, Mary, completing the Glorious Revolution. (Above, PUA; left, PUAM.)

Two

REVOLUTIONARY COLLEGE

In November 1756, College of New Jersey president Aaron Burr Sr. and his students packed their bags and mounted their horses for the trip through Elizabeth and New Brunswick to Princeton. Upon arriving, they found the largest building in the colonies awaiting them. Workmen were still on the job when classes began on November 28, in what was increasingly called "Princeton College."

The initial optimism was soon blighted by the death of Burr, who had rescued the college in the dark days after the death of the college's first president, Jonathan Dickinson. Burr had taken on the college when it was in danger of collapse and left it with a growing reputation and very impressive home; recruiting his renowned father-in-law, Jonathan Edwards, to succeed him brought great promise that was dashed by his death after two months. The early deaths of the next two presidents, Samuel Davies and Samuel Finley, left the college weakened after having five presidents in two decades.

With their passing, the work of the first generation of New Light and Log College founders came to an end, bequeathing over 100 students in the largest college building in the colonies. Its graduates were spreading out across the colonies as New Light ministers and civil leaders. Princeton was established as the center of American Presbyterianism—a role it maintained for over a century.

In the search for a successor, the trustees looked across the Atlantic to the Presbyterian heartland of Scotland and convinced Rev. John Witherspoon to cross the ocean. His presence calmed the New/Old Light schism, and he emerged as the leading Presbyterian in the colonies. He modernized the curriculum, centering it on Scottish Realism, with its conviction that science and religion were reconcilable.

Soon, more dramatic events overtook the college. Students displayed rebellious feelings from the time of the Stamp Act. Witherspoon supported them and committed himself to the Revolutionary cause, becoming the only minister to sign the Declaration of Independence; the revolution was soon at his doorstep. On January 3, 1777, George Washington's troops won a desperately needed victory in Princeton, partially fought around Nassau Hall, which became a target of Alexander Hamilton's artillery.

Classes resumed in summer 1777, but the college struggled with Nassau Hall having been devastated and a president more likely to be in Congress than a classroom. In 1783, Nassau Hall once again became the site of momentous events. During a meeting there, word arrived of the Treaty of Paris recognizing the independence of the United States. And General Washington came to retire his commission and sit for a portrait that still graces the Faculty Room.

OVERLOOKED FOUNDER. After an auspicious start, Nassau Hall soon experienced setbacks. Aaron Burr Sr. (left), arguably the unsung hero of the college's founding, had taken on the college when it was only months old and in danger of collapse. He taught much of the curriculum himself and raised the college's respectability. Along with the trustees, he oversaw the fundraising that underwrote construction of the largest structure in the colonies and the move to the new site that would become a historical landmark celebrated with a stamp (below) on its 200th anniversary. All of this left Burr exhausted, probably contributing to his death less than a year after opening Nassau Hall in 1756. Poignantly, among the extra duties he took on in his last months were preaching at Gov. Jonathan Belcher's funeral and making the long trip to see his father-in-law, Rev. Jonathan Edwards, in Stockbridge, Massachusetts. (Left, PUAM; below, WBL.)

"In the Hands of an Angry God."
As the leading theologian in the colonies, Jonathan Edwards (below) was the trustees' choice to succeed his late son-in-law Aaron Burr Sr. (standing tombstone at right), an appointment that dramatically raised the college's prestige, especially among Calvinists. Edwards's famous sermon suggested his theological fierceness. Despite igniting remarkable religious revivals, he lost his pulpit for demanding excessive proof of a conversion experience. Then, literally in the wilderness, he wrote his classic *The Freedom of the Will*, which led to his election as president of the College of New Jersey. Although he was hesitant at first, he finally agreed to succeed Burr. Edwards arrived at Nassau Hall in January 1758 and made a profound initial impression. Unfortunately, an attempt to protect him from smallpox—a common threat in Princeton—backfired when the inoculation had fatal repercussions; he had been in office for only two months. (Right, HSP; below, NPG.)

THE SCOTTISH CONNECTION. The first five presidents of the College of New Jersey died in office during the school's first two decades. Needing strong leadership to stave off threats from Old Light Presbyterians and the Anglican governor, Benjamin Franklin's son William, the trustees turned to the Presbyterian homeland of Scotland. The search for an eminent theologian who had not been part of the Old/New Light controversies led to Rev. John Witherspoon (left) of Paisley, Scotland. Richard Stockton ('48) traveled to Scotland to deliver the invitation. He convinced Witherspoon but not his wife, Elizabeth Montgomery Witherspoon, who feared winding up a widow in a strange land. Fortunately, Benjamin Rush ('60, below) was studying medicine at the University of Edinburgh, the leading medical school of the time; he crossed the Scottish Lowlands to Glasgow and used his medical knowledge to overcome Mrs. Witherspoon's fears. (Left, PUAM; below, NPG.)

ACADEMIC INFRASTRUCTURE. Rev. John Witherspoon and his wife arrived in Philadelphia in August 1768 to a rapturous welcome. However, he found the college in a weakened condition, with poor finances and limited resources. The library pictured above replicated the school's holdings before Witherspoon arrived. Adding his personal library considerably increased the number of books available to students, especially those emanating from the Scottish Renaissance. Although he was recruited as an orthodox Scottish Presbyterian, he proved surprisingly open-minded about changing political and academic attitudes. He was concerned by the limited role of science in the curriculum, and his revisions were informed by Scottish Realism, which preached the reconcilability of faith and science. To highlight the latter's importance, Witherspoon purchased the Rittenhouse Orrery (below), a cutting-edge model of the universe and the first of its kind in the colonies. Unfortunately, the Revolutionary War led to the destruction of much of the library and damage to the orrery. (Above, PUA; below, PUAM.)

A North West Prospect of Nassau Hall with a Front View of

A North West Prospect of Nassau Ho

THE FIRST "CAMPUS." Although the equipment Rev. John Witherspoon inherited was primitive, he was blessed with the largest building in the 13 colonies; it is depicted here in a romanticized setting. The building was set back from Nassau Street and bounded on the west by the president's home. Witherspoon dubbed the enclosed land as the "campus," which the *Oxford English Dictionary*

esident's House in New Jersey J. Fisher Delinet from an old print Jet 1807

A View of the President's House in New Jersey

confirms to have been the first use of the word to denote the grounds of an academic institution. The Witherspoons arrived to find comfortable accommodation—a building that shares the claim to be the oldest on campus (with Nassau Hall) and is now known as the Maclean House. (PUA.)

REVOLUTIONARY LEADER. After the arrival of Rev. John Witherspoon, dramatic events soon overtook the college. Students had displayed patriotic feelings from the time of the Stamp Act and gained the support of the college's president. Witherspoon was Scottish-born and had opposed the 1745 Jacobite uprising, but he quickly became an admirer of American society. He joined the local Committee of Correspondence and then was elected to the Continental Congress, becoming the only minister and college president to sign the Declaration of Independence. In John Trumbull's famous painting, Witherspoon is seated near the right corner of the room. Second to his right is Richard Stockton ('48, seen at left), one of the college's first six graduates, whose treatment as a prisoner of war led to his early death. Witherspoon lost his son James at the Battle of Germantown. Later, Witherspoon was elected to the New Jersey convention that ratified the Constitution and played a leading role in creating the American Presbyterian Church. (Above, NPG; left, PUAM.)

TURNING POINT. George Washington's army suffered a series of disastrous defeats around New York City and barely escaped to New Jersey. Crossing the colony with the British in pursuit, the army passed through Princeton in early December 1776. Rev. John Witherspoon and the students had departed days before. Not far behind was the British army, which converted Nassau Hall into a prison for suspected rebels and sleeping quarters for its troops. Washington's army crossed the Delaware with fighting seemingly finished for the winter and the colonists' hopes looking bleak. But then, Washington directed two brilliant strategic moves that restored hope. A week after surprising Hessian troops in Trenton the day after Christmas, Washington's troops surprised the British garrison at Princeton. They defeated the main force west of town. The remaining British troops sought refuge in Nassau Hall, where Alexander Hamilton's artillery strikes forced them to surrender. (Above, PUAM; right, Yale Art Museum.)

ALUMNI BUILD THE REPUBLIC. Princetonians had almost entirely supported the American Revolution, contrary to what occurred at some other colonial colleges. Many would leave their mark on the new republic, most famously a student John Witherspoon coached on the writings of John Locke: James Madison ('71). And there were others. David Ramsey ('65, left) not only became a leading protégé of Dr. Benjamin Rush ('60), but also wrote some of the earliest histories of the Revolutionary War. Oliver Ellsworth ('66, below) was a member of the Continental Congress and a delegate to the Constitutional Convention. He is credited with crafting the Connecticut Compromise, which broke the deadlock between the large states (led by Madison) and the smaller states (led by William Paterson, '63). Ellsworth become one of New Jersey's first senators and later served on the Supreme Court. (Both, PUAM.)

INDEPENDENCE. Nassau Hall provided the setting for the final scene of the Revolutionary War. The Continental Congress was meeting in Nassau Hall when word arrived that the Treaty of Paris had been signed and the former colonies were now an independent nation. When Gen. George Washington came there to resign his commission, he donated £50 to the battered college. In turn, the trustees convinced him to sit for a portrait. During the Battle of Princeton, a stray cannonball from Alexander Hamilton's artillery had smashed a portrait of King George II, signatory of the College of New Jersey's charter. Charles Willson Peale, a veteran of the battle, painted a replacement canvas depicting Washington and the fatally wounded Scottish general Hugh Mercer, creating one of the college's most treasured possessions, which is resplendent in the frame that survived Hamilton's cannonade. (PUAM.)

VIEW OF NASSAU HALL,
PRINCETON, N.J.
Published by George Thompson.

THE LULL BEFORE THE STORM. This romanticized scene reflects the College of New Jersey just before the Civil War rent it asunder. The foreground between the East and West College dormitories and in front of Nassau Hall was dubbed the "campus" by president Rev. John Witherspoon in what was the first use of that word to denote the grounds of an institution of higher education. Princeton truly was the first "campus," changing American etymological practice from the commonly used "yard"—except at Harvard. The peacefulness of the scene does not convey the mayhem to come or reflect the difficulties the College of New Jersey endured between the Revolution and the Civil War. The Battle of Princeton and occupying armies left Nassau Hall in shambles. The revolutionary reputation helped the college rebound for a while, but in the early 1800s, fires, student riots, and the restricted educational views of a conservative board of trustees brought the college to its knees before its fortunes reversed. (PUA.)

Three

GOD AND MAN AT PRESBYTERIAN PRINCETON

Despite having been the site of the victorious Battle of Princeton and of Congress receiving the Treaty of Paris that confirmed independence, Nassau Hall and the College of New Jersey faced grim realities. Nassau Hall had been bombarded in battle and vandalized by occupying armies. Despite meeting there in 1783, Congress was slow to allocate promised compensation. Occasional gifts and rising enrollments improved finances, but Pres. John Witherspoon's unsuccessful fundraising trip to Britain reflected a cost of independence.

Students eventually reappeared, and life at the College of New Jersey slowly returned to normal. Teaching increasingly fell on Samuel Stanhope Smith, Witherspoon's son-in-law. The president was preoccupied with politics, then his health failed. Smith's presidency began successfully but fell afoul of student unrest, a devastating fire, and conservative trustees who decided he was too committed to the Enlightenment and producing too few ministers. In 1812, Smith was eased out just as Princeton Theological Seminary moved down the road and away from rowdy undergraduates.

The following decades saw tight control by Presbyterian trustees over the curriculum and undergraduate life. Enrollment slumped at many colleges in the Jacksonian era, but it was especially severe at the College of New Jersey. Pres. Ashbel Green's attempt to crack down on student vice literally backfired as students let off a large explosion, and several riots followed.

For a successor, the trustees passed on Philip Lindsley, a faculty member who became a nationally prominent reformer, in favor of Rev. James Carnahan, an ineffectual but long-standing president from 1823 to 1854. Enrollment continued to decline so much that rumors circulated about the college's closure. The slump bottomed out in the 1830s thanks—in part—to mathematics professor John Maclean, who convinced the trustees to hire bright young faculty members, including star scientist Joseph Henry. At this low point, the formation of the Alumni Association of Nassau Hall, with James Madison ('71) serving as president, provided systemized fundraising that underwrote the construction of dormitories, a refectory, debating society halls, and a chapel.

The curriculum was modernized within the constraints of a board of trustees dominated by Presbyterian clergy from the denomination's conservative wing. The faculty was almost entirely composed of faithful Calvinists, although it included some excellent scholars. Thus, by 1860, the College of New Jersey had healthy enrollments, reasonable finances, and a respectable—if aging—faculty. But it was about to face a new challenge brought on by national events that would sunder an institution with a large southern contingent.

THE WITHERSPOON EFFECT. In this portrait, James Madison points to the Constitution, which was his creation more than anyone else's. A member of the College of New Jersey's class of 1771, Madison remained after graduation to continue his study under John Witherspoon, making him the college's first nontheological graduate student. In total, nine of the 55 delegates at the Constitutional Convention were College of New Jersey alumni, with five having studied under Witherspoon, who had an extraordinary record of training leaders in the service of the new nation. His students included 21 future senators, 39 representatives, 12 governors, and the infamous vice president Aaron Burr, son of the college's second president. Witherspoon led by example. He helped write the Articles of Confederation and served on innumerable committees in the Continental Congress. He retired from politics at the end of the Revolution. His emphasis on training civic leaders deflected many from following clerical careers—a development that undermined his successor. (NPG.)

PRESIDENTS CALLED IT HOME. Today's Maclean House was built alongside Nassau Hall in 1756 as a residence for the College of New Jersey president. It accommodated 10 presidents, starting with Aaron Burr Sr. in 1756 and ending with James McCosh in the 1870s, when the university acquired Prospect House. The venerable structure was then converted into the residence for deans of the faculty and became known as the Dean's House. Alumni think of Maclean House as their first stop on campus, having housed the alumni council for the last half century. Just to the south is the third-oldest building on campus, Stanhope Hall. Built in 1803, it initially housed the first library outside Nassau Hall and the debating societies. Later known as Geological Hall, reflecting another purpose, it has housed many administrative offices since then. (PUA)

DENOMINATIONAL DIVORCE. Samuel Stanhope Smith (left) whose middle name is memorialized via Stanhope Hall, was a talented educator and fitting successor to his father-in-law, John Witherspoon. He guided the college while Witherspoon was preoccupied with Revolutionary politics and, later, while the aging president's health failed. After fire devastated Nassau Hall in 1802, Smith raised enough money to repair the main building and construct Stanhope Hall and Philosophical Hall. But Smith's theological and disciplinary liberalism made him enemies among the trustees. After an 1807 student riot, the Presbyterian General Assembly decided to separate theological students from the unruly undergraduates. In 1812, Smith was forced out at the college, and ministerial training was moved to the new Princeton Theological Seminary. The seminary's first building, Alexander Hall (below), was soon housing future clergy as well as providing a refectory, a lecture hall, and the seminary's library. (Left, PUAM; below, HSP.)

WE SHALL GIVE. The College of New Jersey's fortunes sank in the 1810s and 1820s. Pres. Samuel Stanhope Smith's successor, Ashbel Green, proved that an iron hand did not eliminate student disruptions—but did effectively reduce enrollments. Green, who was more interested in fundraising for the Princeton Theological Seminary than the college, left the latter near bankruptcy. His successor, James Carnahan (class of 1800), served the longest presidential term in the college's history up to that point, but he was also one of the least effectual leaders. Fortunately, a young professor and future president, John Maclean (class of 1816, right), repaired the financial base by organizing the college's alumni association in 1826 and convincing James Madison (below, right pane) to accept the presidency. Alumni had previously made sporadic bequests—starting with the Leslie Fund, which was endowed by a member of the class of 1759—but the alumni association launched systematic fundraising. Madison modeled his role, contributing regularly and leaving a $1,000 bequest to the college's library. (Both, PUAM.)

A Famous Call for Lunch. The messages Joseph Henry sent from his Philosophical Hall laboratory (above)—transmitted along a wire crossing the front of Nassau Hall—to his wife, Harriet Alexander Henry, in their house were, arguably, the first telegraph messages. Henry's moral reservations about patenting scientific breakthroughs led to credit for the invention going to Samuel Morse. Henry had already pioneered the electromagnet when the trustees called him to Princeton in 1832 for a generous salary and a house that would be built to his design. His presence greatly enhanced the college's battered reputation. He taught the whole range of science classes, modernized the scientific equipment, and conducted pioneering research. In 1846, he left to become the first head of the Smithsonian Institution. The Joseph Henry House (below) has since been moved from next to Stanhope Hall to the east side of the front campus across from the Maclean House. (Both, PUA.)

TWO SIDES TO EVERY QUESTION. Princeton's venerable Whig and Cliosophic literary societies date to pre–Revolutionary War times. Originally housed in Nassau Hall, the societies gained their own quarters when Stanhope Hall opened in 1803. Debates continued there until twinned halls were constructed in the 1830s in the Greek Revival style to reflect the origins of political debate. The rivalry between the societies dominated student life and became exceptionally bitter as slavery and abolition became pressing issues. (PUA.)

THE DINING DILEMMA. Colleges struggled to fulfill the ideal of a residential community—an invented tradition rarely realized. Life at the College of New Jersey was quite spartan in the 50 years after the Revolution. But in the 1830s, the College of New Jersey began undertaking construction of the requisite facilities. Unfortunately, the refectory was unsuccessful and soon closed; it was not replaced until 1917. (PUA.)

STUDENTS CALLED IT HOME. As enrollment recovered in the 1820s and soared in the 1830s, Nassau Hall could no longer house all students. In 1833, the college's first purpose-built dormitory, East College, opened behind Nassau Hall. Across Cannon Green, its twin, West College (now Morrison Hall), opened to students three years later, forming a pleasing quadrangle with Nassau Hall on the north and Whig and Clio Halls to the south. (PUA.)

GOD'S HOME IN PRINCETON. The college's earliest religious services were held in the rectories of College of New Jersey presidents Jonathan Dickinson and Aaron Burr. Nassau Hall's prayer hall, the meeting place of the Continental Congress in 1783 and today's Faculty Room, accommodated college religious services for nearly a century. This first purpose-built chapel opened in 1847 and was in use until 1882, when rising enrollments required a larger structure to accommodate required chapel attendance. (PUA.)

NASSAU HALL REDUX. Nassau Hall's elegant central stairway with three doors leading into a two-story open space decorated with Doric columns proved to be a wind funnel for fires that left only walls standing in 1802 and again in 1855. Architect John Notman narrowed the front entrance, moving two doors to the ends of the building and topping them with Italianate towers. The stairways remain, but the ungainly towers were removed in 1905. (PUAM.)

CLEAR THE TRACK. A steam railroad connected the college to New York City and Philadelphia in the early 1840s, making Princeton less remote and offering students unapproved temptations. Students were divided on the issue of slavery—largely on regional lines. After secession, Southern students departed, accompanied by Northern students bidding poignant farewells at the train station, allegedly leading to the creation of Princeton's "locomotive cheer." During the Civil War, 70 Princetonians died, with the deaths evenly divided between the Confederacy and the Union. (PUA.)

LAUNCHING THE COUNTRY'S AUTUMNAL FIXATION. At the heart of the new student culture was an emerging game that has come to dominate campus life in the fall. The 150th anniversary of collegiate football, which was recently celebrated across the country, dates from an 1869 game played between Rutgers and Princeton (above). The barely organized chaos bore a faint resemblance to the modern game, but it is widely accepted as the birthplace of these battles and their accompanying anthems, totems, and tailgates. By the 1880s, football was central to collegiate culture and started drawing loyal fans from beyond campuses. The Princeton–Yale Thanksgiving game in New York City even caused the famous minister Henry Ward Beecher to change the time of his service to accommodate parishioner fans (below). Unfortunately, growing pressure to win yielded questionable practices on and off the gridiron, eventually leading to reforms. (Both, PUA.)

Four

THE ROMANCE OF COLLEGE LIFE

The austere campus life that fomented student resentment and even riots at the College of New Jersey and other campuses changed dramatically after the Civil War. Students across the country fashioned their own collegiate culture, rejecting the older generation's Victorian strictures on physicality and leisure activities such as drama, cards, and dancing while opting for "muscular Christianity" and a more robust social life. Athletic prowess and successful leadership of student organizations threatened to—and often did—overshadow academic achievement and piety.

College newspapers spread the new collegiate culture, and athletic contests and touring musical groups brought students together across campuses. Some events, such as the Princeton–Yale Thanksgiving football game, became major social events and captured the imagination of the public. Magazines conveyed a romanticized campus life and spread collegiate styles among their upper-middle-class readership.

College presidents, trustees, and faculties initially resisted and fought a losing generational battle while trying to steer students back toward debating societies, religious enthusiasm, and noncompetitive gymnastics. The more affluent colleges, like Princeton, eventually saw the possible advantages and adjusted their ideal of a college community, channeling it to attract new students and unprecedented funding. Soon, with handsome dormitories, dining halls, gymnasiums, athletic fields, and chapels, tranquil campuses exuded a sense of tradition from a past that had never existed.

The result, although it drew inspiration from Oxford and Cambridge, became a uniquely American cultural phenomenon. Not only were campuses transformed, but collegiate life entered popular culture, inspiring loyalty for athletic teams and attracting audiences from beyond the campus for cultural events.

The College of New Jersey, which became Princeton University in 1896, was a leader—and even a model—for the male version of this new collegiate life. The trustees and faculty of the College of New Jersey that emerged after the Civil War could hardly have envisioned the changes to the campus and students' lives over the next half century. The famous 1869 Rutgers–Princeton football game foretold the future. College of New Jersey president James McCosh and his successors could only hope to direct the student culture in positive directions and reap the benefits it brought in enrollment and previously unimaginable funding. By the time of World War I, Princeton was regulating the more egregious temptations of student life, especially breaches of athletic eligibility, and establishing administrative mechanisms to regularize student affairs. The school was reasserting a more permissive and comfortable form of *in loco parentis*.

In the Gym. Pres. James McCosh hoped that gymnastics would draw students away from football and other competitive sports and their attendant excesses. He immediately commissioned the construction of Bonner-Marquand Gymnasium and hired fellow Scot George Goldie as the director. A legendary gymnast, Goldie guided the program for four decades. Initially, his students just gave exhibitions at commencement and in the area, but after 1900, gymnastics also became a competitive sport. (PUA.)

On the Water. Rowing formally launched at the College of New Jersey with the construction of a boathouse in 1872 along the Delaware and Raritan Canal. Because the canal was a busy commercial thoroughfare, it was far from ideal, but enthusiasm prevailed. In 1874, the Great Intercollegiate Regatta, hosted by Syracuse University, included teams from eight colleges, including Harvard, Princeton, and Yale. The crowd, estimated at 25,000, foretold how intercollegiate athletic teams were starting to attract public attention and loyalty. (PUA.)

A HOME FOR ATHLETICS. Arriving at the school before crew and football, baseball is Princeton's oldest competitive sport. Baseball games against amateur teams in Orange, New Jersey, and elsewhere predated the Civil War. The first collegiate game ended in a loss to Williams College in 1864. Four years later, the team may have initiated the concept of the Big Three, losing to Harvard and Yale while touring New England. Players from the college contributed to baseball's modernization, playing a role in developing the hook slide, the curveball, and the chest protector. Games were originally played between Clio Hall and the railroad tracks (above). University Field (laid out on what is now the engineering quad) became the terminus for many reunion parades followed by the Yale game. Osborn Clubhouse (below), built adjacent to the field in 1892, provided facilities for dressing and pregame meals. Many alumni will remember training meals held there through the 1960s. (Both, PUA.)

COLLEGE FOOD. The image of college students rooming and dining together on campus is, in fact, an invented tradition. It had rarely been true, even at Princeton. Nassau Hall was constructed with a kitchen, but rising enrollment outpaced it, and thin wallets drove some elsewhere. With the banning of fraternities and the closing of a short-lived refectory in the mid-1850s, students had to eat in boardinghouses or form eating clubs. Most were temporary, including the Alligators (above), whose members included hatless future president Woodrow Wilson. But in the early 1880s, more permanent groupings formed, and wooden houses were purchased or built, like Cap and Gown's first home (below). By 1900, seven permanent clubs (Ivy, Cottage, Cap and Gown, Colonial, Cannon, Elm, and Tiger Inn) fed about one quarter of the student body, with the vast majority still dining in boardinghouses. (Both, PUA.)

THE CLASS DIVIDE. As the College of New Jersey attracted wealthy industrial families, demand for more commodious accommodation grew. When Witherspoon Hall (above) opened in 1877, it was considered one of the most luxurious dormitories in the country, complete with provisions for servants. Although college president James McCosh courted wealthy families and the hall was named for his Scottish Presbyterian predecessor, he was offended by its excesses and feared that the rising number of Episcopalian students threatened to squeeze out the less affluent, especially those destined for the ministry. To counter the impression that the college had become a "rich man's" school, McCosh oversaw the construction of the spartan Edwards Hall (below), appropriately named for the college's third president, who was an evangelical firebrand. It quickly developed a reputation as a "Poler's Paradise," a disparaging term for those seen as overly serious students. (Above, Princeton University Library; below, HSP.)

BACK TO THE FUTURE. After the school was renamed Princeton University at its 1896 sesquicentennial celebration, it adopted an architectural style that provided borrowed prestige, especially by echoing Oxford and Cambridge. The previous architectural eclecticism was replaced by a committed embrace of the Collegiate Gothic style, which became a Princeton hallmark. The style matured at Bryn Mawr College under architects Walter Cope and John Stewardson, who were soon hired at Princeton. Their Blair Hall (above), Little Hall, and University Gymnasium gave those arriving by train a grand introduction to the campus. After the early deaths of Cope and Stewardson, Ralph Adams Cram, then the nation's best-known practitioner of Collegiate Gothic, controlled the college's architecture for a generation. His Holder Hall, Hamilton Hall, and Madison Hall quadrangles housed and dined students in Gothic magnificence. Across Nassau Street, Lower (below) and Upper Pyne offered half-timber versions of the Tudor Gothic style. (Both, PUA.)

MATERNAL CARE. Pres. James McCosh's wife, Isabella, the daughter of a leading Scottish doctor, carried on the family tradition, viewing treating sick students as her duty. Legendarily, upon learning a student was ill, she would load a basket with clean linen and homemade foods and head for his room. Thus, when the trustees funded the college's first infirmary in 1892, it was named for her—as was the present infirmary, which was dedicated in 1924. (PUA.)

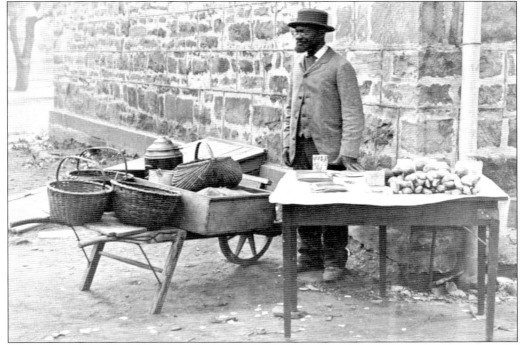

FROM FUGITIVE SLAVE TO CAMPUS ICON. Like Frederick Douglass, James Collins Johnson escaped his enslavers in Maryland in the late 1830s. Students helped him to procure his freedom, and Johnson became a leader in Princeton's Black community. He pursued entrepreneurial activities on the campus and in town, becoming widely known among students. *The Princeton Fugitive Slave,* a biography by Lolita Buckner Inniss, insightfully examines Johnson's life and the interactions he had in the segregated town-and-gown community. (PUA.)

GOD AND MAN AT PRINCETON. The college's earliest religious services were held in the rectories of the first two presidents. Nassau Hall's prayer hall (now the Faculty Room), which served as the meeting place for the Continental Congress in 1783, accommodated college services for nine decades. In 1847, the college's first purpose-built chapel opened, but it could not accommodate rising post–Civil War enrollment. In 1882, Henry Marquand donated a larger chapel. When this was razed to make way for Pyne Library in 1896, a second Marquand Chapel, designed by Richard Morris Hunt, a favorite of wealthy Presbyterians (including Marquand), was constructed on the site of the current chapel (above). The stunning Tiffany stained-glass windows decorating the Romanesque structure would have offended earlier Calvinist sensibilities. The second Marquand Chapel succumbed to a fire in 1920 that also destroyed the original Dickinson Hall. (Both, PUA.)

MUSCULAR CHRISTIANS. Collegiate student culture adopted a later version of Victorian Christianity dubbed "muscular Christianity." It extolled physicality and could be easily integrated with—and even used to justify—the fixation on intercollegiate athletics. Daniel Chester French's *The Christian Student* statue epitomized that ideal with a student wearing an academic gown over his football uniform and carrying books under his arm. The student whom it memorialized, Earl Dodge ('79), exemplified those attributes. He founded the Philadelphian Society, Princeton's version of the Intercollegiate YMCA, which had chapters that enrolled an extraordinary number of students across the country. As president of the Philadelphian Society, Dodge presided over its meetings in Murray Hall (above). After Dodge's early death, a second building was attached in his honor, creating what has since been known as Murray-Dodge Hall (below). Erected in 1913, *The Christian Student* faced the dual building. (Both, PUA.)

NEAR AND YET SO FAR. Although Princeton remained essentially an all-male school until the 1970s, the presence or absence of women was a constant fixation for undergraduates. For a brief time, a women's college was located within walking distance. Evelyn College for Women (above), founded in 1887 by retired Princeton professor Joshua Hall McIlvaine, was located about a mile from the College of New Jersey and enrolled a modest number of women, shown posing in a stylized photograph. Although Evelyn College was legally separate from Princeton, Evelyn College's trustees included Pres. Francis Landey Patton and Provost James Ormsbee Murray, senior faculty lectured there, and many students had familial ties to it. Weakened by the 1893 depression, Evelyn College closed after McIlvaine's passing in 1897. On the west side of Princeton, Miss Fine's School (below) provided a college-preparatory curriculum for young women. It was founded in 1899 by May Margaret Fine, one of three Fine siblings who left an indelible impact on Princeton. Her school lives on, having merged into Princeton Day School. (Both, PUA.)

IN LOCO PARENTIS. Younger faculty members—especially those who had joined the scholarly exodus to Germany, where overseeing social life was not considered part of universities' remit—resented being expected to take attendance in chapel or perform other tasks regulating student behavior. Increasingly, that role was taken over by the administration, which hired proctors to navigate youthful challenges to constraining rules. (PUA.)

AT LAST, A STAGE. In a reflection of changing religious views and alumni support of the arts, in 1895 the college constructed the Casino as a place for student performances as well as dances, tennis, and bowling. In effect, it was the first student union. It housed the Triangle Club (shown rehearsing) for three decades of musical comedy. A fire that burned down the building in 1924 led to the construction of the much more commodious and professional McCarter Theatre. (PUA.)

THE STREET. The wooden clubs were succeeded in the new century by lavish stone and brick buildings that drew national attention when Princeton president Woodrow Wilson attacked their elitism. The seven permanent eating clubs (Ivy is shown above, and Terrace is shown below) created by 1900 were soon joined by six more (Campus, Charter, Key and Seal, Quadrangle, Terrace, and Tower). These expanded the number of undergraduate members but still left out many whose social condition Wilson labeled "deplorable." Although Wilson preferred "clubbable" students and faculty, the clubs' growing influence on campus culture and their rivalry with academic pursuits led him to lament that the "side shows . . . have swallowed up the circus." President Wilson launched planning for a freshman and sophomore commons to delay dividing classmates among clubs. But rejection of his quadrangle plan to reintegrate academic and social life by subordinating upper-class clubs helped lead to his acrimonious departure. (Both, PUA.)

CALVINISTS GET RHYTHM. The arts started slowly at Princeton, reflecting its Calvinist origins. Pres. John Witherspoon wrote that theater and Christianity were incompatible, and some questioned having an organ in the original Nassau Hall chapel. Before the arts entered the curriculum, students founded the Glee Club in 1874, and other musical organizations soon followed. The Princeton College Dramatic Association, founded in 1883, performed serious drama before shifting into musical comedy and morphing into the Triangle Club a decade later. Booth Tarkington wrote Triangle's first venture, *The Honorable Julius Caesar* (right), as a spoof of Shakespeare's classic. The Shakespeare Club took a somewhat more serious approach to the Bard (below). In 1901, the Triangle Club went on the road to New York City, and trips to the Midwest became a Christmas tradition. After the 1913 show in Washington, DC, the cast was entertained at the White House by former Princeton president Woodrow Wilson. (Both, PUA.)

EXERCISING THE MIND. The Whig and Cliosophic Societies once powerful hold on students lessened as athletics, other organizations, and eating clubs drew them in. Admission to the societies was highly valued in the college before the Civil War, but by the 1870s, college president James McCosh was upset that many students declined to join. Alumni shared the administration's concern and raised money for new marble buildings to replace the decaying 1830s stucco structures. At the 1890 commencement (above), cornerstones were laid for twin buildings with 20-foot Iconic columns and spacious libraries and meeting rooms. The new buildings (below) and intercollegiate debating briefly revived the societies in the 1890s before their numbers again declined. Some potential members were no doubt drawn to *The Nassau Lit,* the second-oldest college literary magazine (established in 1842) and the *Daily Princetonian,* the student newspaper founded in 1876. (Both, PUA.)

AN ACADEMIC PROCESSION AT PRINCETON *Photo. Brown Bros.*

Woodrow Wilson in the center in cap and gown as president of the university. At his left is Andrew Carnegie, on whom the university conferred the degree of LL.D.

PRINCETON GETS A LOCH. Despite his smile, Woodrow Wilson was anything but pleased as he escorted Andrew Carnegie to the dedication of his loch on December 5, 1906. Woodrow complained that he had asked the Scottish steel magnate for bread (i.e., a law school or library) and instead got cake. Wilson's attempts to restrict use of the loch were to no avail. Rowers were delighted, as they were no longer confined by the narrow banks and competing crafts of the Delaware and Raritan Canal. Instead, Princeton now had one of the premier rowing lakes in the country and began hosting regattas on the 3.5-mile course. Townspeople were also pleased to have a place for ice-skating, sailing, fishing, and hockey. Draining the marsh also reduced the number of attacks from the legendary Jersey mosquito. (Both, PUA.)

PRINCETON'S GREATEST STAR.
Princeton produced many famous
athletes in the decades before
World War I, including—somewhat
incongruously—the six Poe brothers,
descendants of the lugubrious poet
Edgar Allan Poe. However, one
Princeton athlete achieved legendary
status: Hobey Baker, an All-American
halfback, achieved even more renown
as one of the greatest hockey players of
all time. Baker served as an aviator in
France during World War I, and he died
in a crash shortly after the armistice.
His name is memorialized at the Hobey
Baker Memorial Ice Rink. (HSP.)

PRINCETON'S GREATEST LOSS. Of the 14 universities in Edwin Slosson's 1910 classic *Great American Universities*, only Princeton barred the admission of African American students. The most notable consequence was that Paul Robeson, who had spent his childhood in Princeton where his father was a minister, enrolled at Rutgers College, where he excelled in both athletics and academics. At graduation, he delivered the valedictory oration and then helped the Rutgers baseball team defeat Princeton. (NBPL.)

GOING BACK. Although support for the post–Civil War building boom initially came from industrialists—especially those with Scottish and Scotch-Irish ancestry—the alumni connection increasingly drove fundraising. The Princeton Alumni Association, which had been in existence since 1826, assumed an increasing role in university affairs, sometimes to the discomfort of administrators, as Woodrow Wilson found out. Alumni loyalty was enhanced by traditions like the 1891 Class Day (shown at right). Many alumni maintained a lifelong connection through the *Princeton Alumni Weekly* (*PAW*), which was founded in 1900 as an independent alumni voice. *PAW* supported big-time athletics and the social clubs on Prospect Street as well as providing postgraduation intellectual stimulation. The publication's letters to the editor featured a wide variety of opinions on university policies. Loyalty is further enhanced by Princeton's legendary annual reunions, which attract thousands of alumni and their families. At right, the class of 1856 is pictured 60 years after their graduation. (Both, PUA.)

INTO A NEW CENTURY. The faculty members bequeathed by Pres. John Maclean Jr. to James McCosh in 1868 (above) would not have recognized the campus of 1900 beyond the old core surrounding Nassau Hall. This romanticized rendition of the campus of the newly renamed Princeton University shows its dramatic growth and gentrification (below). To the east of Nassau Hall were the new Pyne Library and academic buildings as well as Marquand Chapel. To the west, dormitories dominated, surrounded by a gymnasium, an observatory, and the unique ceremonial Alexander Hall. Those arriving by train after 1898 were greeted by the grand vision of Blair Hall on the west side of campus—an iconic model of the Collegiate Gothic style of architecture that became a Princeton hallmark. (Both, PUA.)

Five

BECOMING
PRINCETON UNIVERSITY

In 1896, between the Civil War and World War I, the College of New Jersey morphed into Princeton University, signifying potentially momentous change. James McCosh's arrival from Scotland in 1868—exactly a century after John Witherspoon's emigration—triggered a reset for an institution in need of renewal. President McCosh modernized the curriculum, brought in talented young faculty, and successfully raised funds to expand the campus, especially playing on his connections to Scottish and Scotch-Irish communities. McCosh also hoped to adjust Princeton to the emerging research university model.

But McCosh's successor, Francis L. Patton, bragged that he presided over "the best country club" on the East Coast. While many students liked that atmosphere, younger faculty and trustees grew restive. Patton and older trustees did not share McCosh's ambition to join the burgeoning ranks of American research universities. Although that aspiration was given formal recognition at the 1896 sesquicentennial with the addition of "University" to the school's name, little was done to warrant it.

McCosh's "bright young men" on the faculty later had their revenge. In 1902, they began plotting with some younger trustees, and Patton was edged out and compensated with the presidency of Princeton Theological Seminary. As planned, Prof. Woodrow Wilson succeeded him.

Wilson and his dean of the faculty, Henry Fine, set out to reorganize the undergraduate curriculum and create a faculty worthy of a research university. For the former, they immediately raised academic standards and dismissed a shocking number of underachieving undergraduates. Then, Wilson convinced the trustees to fund his preceptorial scheme, hiring 50 young faculty members to staff seminars. He also reorganized the curriculum into two years of breadth followed by two years of specialization, a structure that was later adopted by allies at Harvard and rapidly spread across the country and influences American curricula to this day.

Although Princeton was a founding member of the Association of American Universities, organized in 1900, the university hardly deserved the honor. The Princeton Graduate School, only established that year, had few students and little appropriate curriculum. The first dean, Andrew West, was more committed to Oxbridge-style ceremony than participating in the rapidly changing world of research. However, the less noticed Dean Fine was building a powerful mathematics and science faculty.

After a brilliant beginning, Wilson fell afoul of alumni and trustees who opposed his plan to create an Oxbridge-style college system that endangered both the prestigious eating clubs and West's dream of a sumptuous graduate college. After resigning to enter politics in 1910, Wilson left behind a transformed institution, socially envied and academically respected.

HOME IN AMERICA. Isabella and James McCosh's first American home was the venerable presidential house built alongside Nassau Hall in 1756 and now known as Maclean House (above). Whereas the center of the college had once been the campus in front of Nassau Hall, the locus was moving south. In 1878, McCosh's fellow Scottish Presbyterians and wealthy merchants Alexander and Robert Stuart purchased Prospect (below) to be used as the McCosh's residence. The name was derived from the campanile's view that once extended almost to the ocean. Architect John Notman, who had redesigned Nassau Hall after the 1855 fire, again employed the fashionable Italianate Villa style. President McCosh delighted in the building, grounds, and view, declaring that he lived in the best college president's house in the country. (Both, PUA.)

REUNION. The Presbyterian Church had been sundered by sectionalism and the ensuing conflict over slavery. Princeton, with its large Southern enrollment, had been especially divided. Thus, when the trustees chose a new president in 1868, James McCosh offered the additional attraction of having been distant from the schism. In a similar spirit, Reunion Hall, the name of the first dormitory built after the Civil War, commemorated the Presbyterian church's 1869 reunification. (PUA.)

CHAMBER OF HORRORS. Expanding enrollment required more classrooms. John Green, descended from Jonathan Dickinson, the College of New Jersey's first president, donated a classroom building and named it Dickinson Hall in honor of his ancestor. Two floors of classrooms were topped by a capacious third-floor room used for examinations (dubbed the "chamber of horrors" by students), lectures, and even a banquet for Pres. Ulysses Grant. The plain 1870 exterior soon received Gothic ornamentation. (HSP.)

HITTING THE BOOKS. The building boom continued under James McCosh. In 1873, Chancellor Green, the college's first purpose-built library, opened. Named for the then chancellor of New Jersey, its Ruskinian Gothic design makes it intriguing from the outside and inside. Timber accented the roof and stained glass radiated colors, although it did not provide the best reading light. The main octagonal building was flanked by two wings. Princeton's first librarian, Frederick Vinton, sat at a central raised desk from which he could oversee activity. To access most books, students negotiated a walkaround railed gallery supported by eight cast-iron pillars. To meet the rapidly growing demand, innovative shelving allowed for 80,000 books, although the library initially only contained 20,000. As knowledge exploded, the shelves quickly filled, making the structure inadequate. Now considered a classic of High Victorian Gothic architecture, its ornateness was often ridiculed at the time it was built. (Both, PUA.)

SCIENCE GETS A HOME. Science had always played an important role in liberal education, though the curriculum was dominated by classical languages, literature, and mathematics. But the 19th-century explosion of scientific knowledge necessitated more specialization. A common solution was to establish a separate scientific school, such as Sheffield Scientific School at Yale. That strategy served those of a scientific bent while preserving the more prestigious classical curriculum. Princeton president James McCosh, who accepted Darwinian evolution as confirming God's plan, was determined to increase science's role in the curriculum and created the science program in 1870s. Named for its donor, the John C. Green School of Science, a classic example of High Victorian Gothic architecture, soon arose on the site of today's Firestone Library. After a personal request by McCosh, Green added to his beneficence by endowing a professorship of engineering, which launched another branch of instruction. (Both, PUA.)

SCIENCE'S CAMPUS FOOTPRINT. In addition to curricular expansion and a scientific program, physical engagement with science came to be considered a necessity. For instance, today's Faculty Room and the place where Congress learned of the Treaty of Paris was, from 1873 to 1906, a paleontological museum created by famed geologist Prof. Arnold Guyot. It featured threatening-looking dinosaurs that did not fit a literal interpretation of Genesis. Every respectable 19th-century college also needed an observatory. Although Princeton had prominent astronomers on its faculty, funds were not raised for an observatory until after the Civil War. A 23-inch telegraph lens was installed in 1882 and was the fourth-most-powerful of its kind in the world. A series of distinguished astronomers served as directors of the observatory before it was razed in 1930 to make way for Joline Hall. (Above, PUA; below, HSP.)

NO LONGER PURITANICAL. Finished in 1889, this Romanesque building housed the college's first art museum. Allan Marquand ('74) was the driving force, strongly supported by Pres. James McCosh. Originally hired to teach logic and Latin, McCosh convinced Marquand to teach the history of art and to create the Department of Art and Archaeology—a rarity at the time. To offer a serious program, Marquand needed a museum. Not only was McCosh supportive, but he also selected the site next to Prospect on a knoll he called the Acropolis. It was soon full of an aesthetic version of Victorian clutter. What McCosh called "the once Puritan college" had embraced art. Marquand launched Princeton University Press's first series, the Princeton Monographs in Art and Archaeology. He also started the highly regarded Marquand Library by donating his extensive collection to the university. (Both, PUA.)

"ME BRIGHT YOUNG MEN." Having inherited an aging faculty and facing a conservative board of trustees, Pres. James McCosh decided to rebuild his faculty by preparing talented undergraduates for academic careers. He invited top-ranked undergraduates and some early graduate students to his "library meetings" in Prospect for lively discussions. By the end of the 19th century, nearly half the faculty—including president Woodrow Wilson and dean of the faculty Henry Fine—was staffed with McCosh's protégés. (PUA.)

Leipzig. Universität u. Paulinerkirche.

CATCHING UP TO EUROPE. Pres. James McCosh understood American academic inferiority and convinced most of his acolytes to study abroad, especially in Germany. They joined over 9,000 young Americans who experienced the Germanic academic model of specialized knowledge certified by a PhD. American students formed academic colonies as at the University of Leipzig, where future Princeton dean of the faculty Henry Fine received his doctorate. Many of those who returned with a doctorate were hired at the university. (WM.)

DEBATING THE FUTURE. In the late 19th century, there was continual discussion of American colleges' tradition of a prescribed curriculum and of stringent *in loco parents*. In 1885, the 19th Century Club invited James McCosh (below) and Harvard president Charles Eliot (right) to engage in a high-profile debate on the issues. Eliot famously championed the elective system—or, more truly, non-system—that allowed students to choose most courses without a structure. Eliot also virtually eliminated oversight of student life and requirements for religious observance. In contrast, McCosh had broadened students' academic choices within guidelines, especially for the freshman and sophomore years, convinced that without requirements, students would opt for what later generations called "gut" courses. He also defended colleges' role in molding the moral and religious beliefs of students. The debates continued into the Wilson years, when the resulting compromises shaped the American colleges of the 20th century. (Right, NPG; below, PUA.)

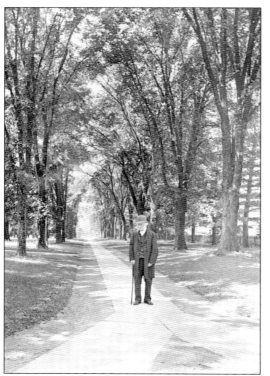

DETOUR ON THE ROAD TO A UNIVERSITY. Retired president James McCosh probably surveyed the campus from his walk with ambivalence. He had modernized Princeton's brick and mortar as well as its academic life. However, the trustees' chosen successor did not share McCosh's ambition to position Princeton among emerging universities. Rev. Francis Langley Patton's reputation for having prosecuted a Presbyterian heresy trial appealed to conservatives on the board of trustees. Oddly, as president, rather than fiercely enforcing traditional Calvinist strictures, he was relaxed about academic life and bragged that he ran the best "country club" on the East Coast. Among the numerous buildings constructed during Patton's presidency was the quirky Ruskinian Gothic Alexander Hall, finished in 1894. It was a showplace for the 1896 sesquicentennial ceremonies and lectures but loathed by champions of Collegiate Gothic, which was soon to be designated the official style of Princeton, ending the college's long-standing architectural eclecticism. (Both, PUA.)

A University in Name Only. The 1896 sesquicentennial provided the opportunity to change the fourth-oldest American college's name from College of New Jersey to Princeton University. The multiday celebration brought in scholars from around the country and leading European universities, including Henry Fine's mentor, German mathematician Felix Klein, giving Princeton the veneer of university status. October 22, designated the official anniversary, began with an academic procession from Marquand Chapel to Alexander Hall for an elaborate academic ceremony and concluded with a torchlight procession overseen by Pres. Grover Cleveland. Finally, the name change was announced—a concession for some and fulfillment of a quest for others. However, Princeton president Francis Patton showed little interest in giving it substance, and a graduate school was not established until 1900. Behind the scenes, discontent grew. Eventually, the McCosh generation had its day. (Both, PUA.)

Georg Brokesch
Klein
Leipzig
Zeitzerstrasse 48.1.

FROM THE TOWN TO THE UNIVERSITY

1746

1896

PRINCETON UNIVERSITY. New Library.

A LIBRARY FOR THE CENTURIES. Despite its stylistic merit, Chancellor Green Library quickly became inadequate for a growing college, especially one with university ambitions. Moses Taylor Pyne ('77), Princeton's greatest donor of the *fin de siècle,* stepped in and donated an eponymous library, which was completed in 1897. Literally attached to Chancellor Green, it dwarfed its predecessor and initially gave Princeton a repository worthy of the newly adopted university title. It was built as a quadrangle with details reminiscent of Oxford—as much as this was possible in central New Jersey. A large reading room served undergraduates, and seminar rooms copied the Johns Hopkins graduate education model. It was predicted that Pyne Library would hold two centuries of books. Instead, it was outmoded by the 1920s, leaving Princeton's library provision lagging behind that of most universities until Firestone Library opened in 1948. (Above, Digital Public Library of America; left, PUA.)

A DISCREET COUP. This headline in the *New York Times* was disingenuous, as the trustees were anything but surprised. Francis Patton's failure to lead, and especially his failure to promote graduate study, alienated younger faculty members. A small group of former students of McCosh—especially Henry Fine, Andrew West, and Woodrow Wilson—communicated via back channels with some younger trustees. Their machinations led to negotiating a golden parachute for Patton, including the presidency of Princeton Theological Seminary. Then, they elevated Prof. Woodrow Wilson ('79) to the university's presidency. (NPG.)

ACADEMIC REVOLUTION. Woodrow Wilson appointed his old friend from his undergraduate days of editing the *Daily Princetonian*, mathematician Henry Fine ('80), as dean of the faculty. Wilson and Fine moved quickly to raise academic standards and modernize the curriculum. Enough students flunked out that the *Daily Princetonian* published a cartoon of a cobwebbed Nassau Hall with no students. The two men reorganized the curriculum to allow upperclassmen to specialize after the breadth of the first two years and integrated the School of Science into the rest of the university. Most dramatically, Wilson convinced the trustees to approve hiring 50 preceptors—promising young faculty members assigned to lead small group discussions and be role models to undergraduates, echoing the roles of Oxbridge tutors. Wilson's classmates built 1879 Hall with a personal office for the president located discreetly in the tower. (Both, PUA.)

MC COSH HALL PRINCETON UNIVERSITY

EMBRACING TRADITION. Although Collegiate Gothic was adopted as Princeton's official architectural style before Woodrow Wilson's presidency, he enthusiastically embraced the style as exhibited by McCosh Hall (above). At the dedication of the Mather Dial (below, a duplicate of one at Corpus Christi College at Oxford), he enthused, with considerable exaggeration, that Gothic architecture added 1,000 years to Princeton's history. More importantly, its connection to Oxford and Cambridge fit Wilson's romantic embrace of those schools and his distaste for the inductive Germanic academic tradition that had alienated him at Johns Hopkins. (Both, PUA.)

SCIENCES ON THE RISE. Science had been a fundamental part of the liberal arts and sciences from the days of the Greeks. After a grounding in the trivium (grammar, logic, and rhetoric) came the quadrivium of astronomy, arithmetic, geometry, music, and astronomy. While science and mathematics remained staples of classical education in American colleges, they lacked equal billing with the arts. With the maturation of the sciences, they began to command equal respect and expensive equipment in purpose-built structures. Woodrow Wilson delegated the hiring of science and mathematics preceptors to dean of the faculty Henry Fine, who proved to have an extraordinary eye for talent. Fine also promoted the construction of Palmer Physical Laboratory (above), which was completed in 1908 and followed a year later by Guyot Hall (below), providing homes for biology and geology. Fine had launched Princeton on the path to becoming a mathematics and science powerhouse. (Both, PUA.)

HUMANITIES. The humanities remained central to the curriculum at Princeton, with composition, rhetoric, and language all retaining important roles. The Department of English was founded in 1904 and strengthened with seven preceptors the following year, leading to a national reputation. The humanities increasingly professionalized, but some maintained a traditional connection to religion. Prof. Henry Van Dyke (right) personified that, having been rector of New York Brick Presbyterian Church and the author of the best-selling *The Other Wise Man*. Princeton president Woodrow Wilson also mined other universities' talents, recruiting stars such as Edward Capps (below) from rivals like the University of Chicago. Capps was a leading campaigner for academic freedom, serving as president of the American Association of University Professors. While Van Dyke strongly opposed Wilson's Quad Plan, Capps was an outspoken supporter. Both men later received presidential appointments from Wilson. (Both, PUA.)

DISSEMINATING KNOWLEDGE. Daniel Gilman, president of Johns Hopkins University, maintained that in addition to creating knowledge, universities should disseminate it, especially that which was too specialized for profitable publishing. In 1878, he founded the first university press; this was followed by the creation of other university presses in the 1890s. Princeton's began in 1905, ahead of those at Yale (1908) and Harvard (1913). Charles Scribner, a leading New York City publisher, was the driving force behind launching Princeton's venture and procured the land on William Street that is still home to Princeton University Press. Prominent faculty members, headed by biologist Edwin Conklin, served on the editorial board and soon attracted impressive manuscripts. Working with Prof. Allan Marquand, the press launched its first series, Princeton Monographs in Art and Archaeology, with copublisher Oxford University Press in 1912. (Both, PUA.)

A University? The Graduate School at Princeton, founded in 1900, hardly justified Princeton becoming a founding member of the Association of American Universities. Most graduate students were pursuing master's degrees part-time. The dean of the graduate school, Andrew West, gloried in the trappings of Oxbridge and did little to encourage students outside of the humanities. In 1905, West installed himself and a small band of students in Merwick, but he harbored bigger dreams. (HSP.)

The Wrong Enemy. The Graduate School at Princeton dean Andrew West dreamed of a graduate college separated from the undergraduate campus by Springdale Golf Club. Princeton president Woodrow Wilson initially supported West's plan but reversed course with his own plan to place graduate students at the center of campus life, mixing with undergrads. This produced important enemies on the board of trustees, including Moses Taylor Pyne, the college's leading donor, who is pictured here on his Drumthwacket estate (now the New Jersey governor's residence). (HSP.)

BATTLE FOR THE UNIVERSITY'S FUTURE. The Woodrow Wilson vs. Andrew West battle over the location of the Graduate School at Princeton became one of the most publicized academic battles in American history. To Wilson's future political benefit, he captured the rhetoric of democracy with his attacks on the elite eating clubs on Prospect Street, which he increasingly saw as enemies of academic life that he hoped to subsume into his Quad Plan. However, his stance earned him opponents among alumni donors and trustees. A windfall handed victory to West, who could glory in presiding over the high table in Proctor Hall (above), and his statue gazes upon the graduate school's spectacular tower (left). Dean of the faculty Henry Fine had a final victory, cleverly wresting control of the graduate school's admission and academic standards. West enjoyed the symbols, while Fine and other more academic faculty steered the graduate school toward academic excellence. (Both, PUA.)

DEFEATED BY THE DEAD. Ruefully, Woodrow Wilson told his wife, Ellen, that he had won the battle with the living but not with those who had passed on when the unexpected bequest handed victory to dean of the graduate school, Andrew West, for his separate campus. Wilson had alienated powerful members of the board of trustees and split the faculty in ways that lasted for a generation. His position became untenable—the look on his face as he headed to the 1910 graduation says it all. Then, luck broke his way. Hoping to take advantage of Wilson's national profile, the New Jersey Democratic Party bosses approached him to run for governor of New Jersey. He won and proved to be a surprisingly independent reformer, leading to his nomination by the Democrats for president in 1912. When Theodore Roosevelt bolted from the Republican Party to run as a third-party candidate and Socialist Eugene Debs polled well, Wilson won an overwhelming Electoral College victory. As president of the United States, Wilson promoted a progressive domestic agenda combined with extending federal racial segregation to its most extreme form. (PUA.)

OVER HERE, OVER THERE. Woodrow Wilson, the former president of Princeton University, campaigned for reelection in 1916 on the slogan, "He kept us out of war." But in the spring of 1917, a perfect storm of events led him to ask Congress for a Declaration of War. Although Wilson and his successor at Princeton, John Grier Hibben (above, first row, second from right), had fallen out over the graduate school controversy, they shared a commitment to vigorously prosecuting the war. President Hibben had been an early spokesman for "preparedness," and he initiated military training courses on the campus in 1915. Thus, with the declaration of war, the campus quickly militarized. Below, students march to dinner. Almost immediately, nearly 100 students sailed for France to join the ambulance corps and other units. Others prepared for combat roles on the peaceful campus. Over 6,000 served, and 151 Princetonians lost their lives, including legendary athlete Hobey Baker. (Both, PUA.)

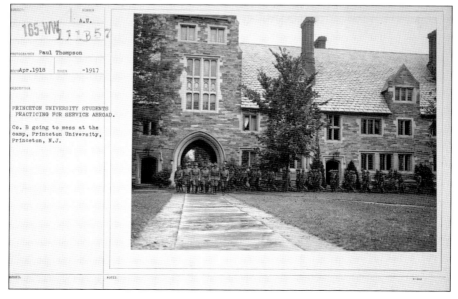

Six

TWO SIDES OF PARADISE

From the onset of World War I through the time the United States dropped an atomic bomb on Hiroshima, Princeton was a deeply dichotomous institution representing two divergent strands of academic life. On one hand, F. Scott Fitzgerald's *This Side of Paradise* amplified Princeton's reputation as an elite country club despite the educational reforms of the Woodrow Wilson/ Henry Fine era. On the other hand, by the 1930s, the university became the international leader in mathematical physics, attracting none other than Albert Einstein, who gave his first major American lectures in Princeton and moved there a decade later after fleeing Germany.

Fitzgerald made Princeton the model of college life, partly shaping an ideal that was an invented tradition. His fictional Amory Blaine lives in a boardinghouse and dines at local eateries. But Princeton was moving to check all the boxes of a traditional college—the social and culinary dilemma of those not served by the eating clubs was finally solved when Madison Hall (or the Commons) opened in 1917 with five Gothic dining halls. Dormitories were built in the center of campus and on the west side in areas freed by moving the Dinky railroad station to the south. A new chapel, observatory, laboratories, McCarter Theatre, and a new McCosh Infirmary further enhanced the campus before the Depression and World War II brought construction to a halt.

Princeton made its mark in the humanities and arts. Fitzgerald was just one of several leading authors produced by an excellent Department of English. Outside the curriculum, the Triangle Club gained fame beyond the campus with its annual Christmas season tours. Edmund Wilson ('16) and F. Scott Fitzgerald ('17) added early luster, and the 1930s saw a galaxy of talent, including Josh Logan ('31), Jimmy Stewart ('32), and Jose Ferrer ('33).

Princeton's greatest intellectual triumph stemmed from a fortuitous intersection of events. Princeton's reputation in mathematics and science, especially physics, continued to grow in the 1920s thanks to dean of the science Henry Fine's exceptional fundraising skills. Fine's sudden death led to the construction of what was arguably the best mathematics building in the country. Oswald Veblen, one of Fine's original preceptors, helped attract the new Institute for Advanced Study (IAS) to Princeton. Since IAS lacked a building until 1939, its members, including Albert Einstein, and the university's Department of Mathematics shared Fine Hall for a golden decade. Their work contributed to saving the world from fascism but opened a window on a scary future.

THIS SIDE OF PARADISE. In 1920, after returning from military duty in France, F. Scott Fitzgerald published his first book, a novel portraying Princeton student life in a memorably romantic light. His fictional alter ego, Amory Blaine, deeply admired the "big men on campus," especially athletes and the editors of the *Daily Princetonian*. Amory Blaine failed to succeed in either group, but the real Fitzgerald showed signs of his future genius by writing the lyrics for three Triangle Club musical comedies. He based the memorable 1915–1916 production *The Evil Eye* on a script by future eminent literary critic Edmund Wilson ('16). Fitzgerald also starred in the production, putting on an acclaimed performance in drag. Unfortunately, he shared the fictional Amory Blaine's academic indifference and never graduated. (Both, PUA.)

INVENTING THE TRADITIONAL COLLEGE. The residential college, with all students sharing dining and rooming facilities, is often dubbed traditional, but it had rarely existed outside small religious colleges until the 20th century. In F. Scott Fitzgerald's *This Side of Paradise*, Amory Blaine often dines in local eateries and initially lives in a boardinghouse, envying those across the street in Campbell Hall (above). This reflected the reality that even after the prewar construction, Princeton could only house about half of its students. In response, after World War I, the Collegiate Gothic dorms that Amory Blaine coveted spread southward across the campus (right), making the "traditional" college a reality at Princeton. Despite his glorification of tradition, Fitzgerald personally reflected Princeton's broadening religious demography as an Irish Catholic who prepared for Princeton at the Newman School yet wrote the classic glorification of historically Protestant colleges. (Both, PUA.)

DINING. Dining had long been a problem at Princeton. After the short-lived Refectory closed in the 1850s, students were left to their own devices. Boardinghouses offered a solution for many. Some of these morphed into groups that built clubhouses—initially wooden "incubator" clubs. Then, starting with the Ivy Club in 1898, fancier eating clubs populated Prospect Street, increasingly dominating social life and drawing Princeton president Woodrow Wilson's ire. As the clubs multiplied (e.g., Cannon Club above), they served an increasing proportion of upperclassmen but left many out and did not serve underclassmen. Finally, this was addressed by constructing the Commons, picturesquely attached to Holder Tower. When the Commons was completed in 1917, all underclassman—as well as those who either rejected or were rejected by the clubs—could finally dine on campus (below). However, Princeton missed an opportunity to establish a residential college system, declining the donations from Edward Harkness that Harvard and Yale accepted. (Both, PUA.)

AFTER BREAD, THE CIRCUSES. Athletics became a fundamental part of collegiate culture in the United States. Big-time sports were important to the student body and many alumni, and they carried the names of the country's colleges and universities into popular culture. Princeton rowing rose to national prominence with Andrew Carnegie's loch, soon augmented by an impressive boathouse (above) just before the war. Princeton's dramatic Palmer Stadium, a rare exception to the dominant Collegiate Gothic architecture that even pleased modernist architect Le Corbusier, attracted crowds and journalistic attention. In 1916, Hobey Baker organized a game-time flyover of 12 planes, an unprecedented aerial feat. His death in World War I elicited an outpouring of philanthropy, including from numerous former rivals, which funded the Hobey Baker Memorial Ice Rink (below). Completed in 1923, it is one of the two oldest collegiate rinks in the country. (Both, PUA.)

LIKE A PHOENIX. A catastrophic fire during the 1920 annual spring house parties destroyed Marquand Chapel, the campus's spiritual home since 1882, as well as the original Dickinson Hall. University architect and mastermind of Princeton's Collegiate Gothic tradition, Ralph Adams Cram, probably wept no tears to see the Romanesque chapel gone, as it provided an opportunity for him to solidify his dream for the campus. The result, the third-largest collegiate chapel in the world, crowned Cram's Princeton career. However, it drew attacks on Princeton president John Hibben from all sides. Traditional Presbyterians resented Gothic's connection with Episcopalianism, and Hibben's hope that its solemn beauty would reverse students' growing skepticism was dashed. He reluctantly acquiesced to student demands to eliminate weekday required chapel. Most of the members of a generation that pulled down the *Christian Student* statue were not going to be converted by architecture, no matter how grand. (Both, PUA.)

A REAL THEATER. The fire that destroyed the barnlike Casino in 1924 was a blessing in disguise, paving the way for a modern theater and new home for the Triangle Club. Seating over 1,000, the brick McCarter Theatre was given a Gothic appearance with a stone facade, pointed arches, and an appropriately Elizabethan interior. Its future augured well with undergraduates Josh Logan ('31), Jimmy Stewart ('32), and Jose Ferrer ('33) on stage for the 1930 opening. (PUA.)

CLASSROOM THEATRICS. Some professors could turn lectures into theatrical performances. Among those was Walter "Buzzer" Hall, whose last lecture was moved to Alexander Hall to accommodate all who wanted to attend. However, more intense learning occurred in smaller venues. Here, Hall leads a precept, Princeton president Woodrow Wilson's innovation to create close interaction between students and faculty members. In 1924, required courses were reduced to provide for independent research that leads to a senior thesis, creating a Princeton tradition. (PUA.)

THE RIGHT CHEMISTRY. With Woodrow Wilson's abolition of the School of Science, the role of natural science in the general curriculum quickly expanded, although facilities sometimes lagged. Chemistry finally caught up with biology and physics in 1928 when Frick Laboratory opened. During World War II, it was used for Manhattan Project research, the results of which were relayed to Los Alamos. (PUA.)

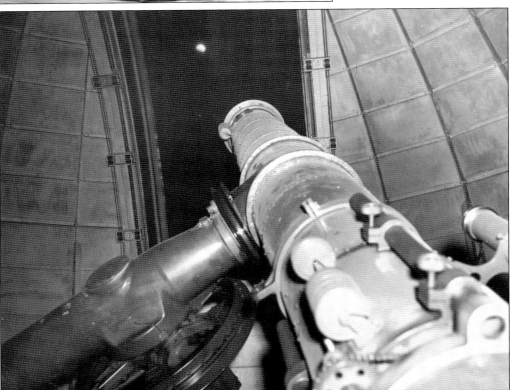

AIMING FOR THE STARS. Princeton had a long history of excellence in astronomy, but Halsted Observatory, in use since the 1860s, was embarrassingly obsolete by the early 20th century. Despite having America's leading astronomer, Henry Norris Russell, on the faculty, Princeton did not replace it until FitzRandolph Observatory was completed in 1934, east of Palmer Stadium and away from campus lights. It achieved unscientific fame for its role in Orson Welles's *The War of the Worlds*. (PUA.)

THE FINE TRADITION. Princeton president Woodrow Wilson appointed mathematician Henry Fine to be dean of the faculty. In this position (and later as dean of science under Pres. John Hibben), Fine spent three decades building Princeton into an international mathematics and physics powerhouse. Wilson had delegated the science and mathematics preceptor appointments to Fine, who displayed an extraordinary ability to identify talent. His initial preceptorial appointments all became respected mathematicians, and he leveraged those appointments to recruit established American and European mathematicians. By 1911, Princeton's Department of Mathematics ranked among top three in the United States and published the prestigious *Annals of Mathematics*. Thus, on his first trip to America in 1921, Albert Einstein chose Princeton for his lectures. Appropriately, Fine met him at the boat, and Princeton University Press published the lectures, which became Einstein's definitive description of his theory of relativity. (Both, PUA.)

INTERNATIONAL LEADERSHIP. With the Graduate School at Princeton languishing, dean of the faculty Henry Fine seized academic control from Pres. Woodrow Wilson's archenemy, dean Andrew West, and turned Princeton into a leading research university. Fine compiled a remarkable record of fundraising in the 1920s, and his final legacy resulted from his tragic death. In response, his close friend and wealthy Princeton trustee Thomas Jones funded construction of Fine Hall, the best mathematics building in the country. Finished in 1931, Fine Hall coincidentally became the first home of the new Institute of Advanced Study, including its most distinguished faculty member, Albert Einstein, until a separate building was completed in 1939. The institute's first faculty member, Oswald Veblen (below with Einstein), one of Fine's original preceptors, befriended Einstein and used his position to rescue leading academics from fascism. (Both, PUA.)

PRINCETONIANS IN THE NATION'S SERVICE.
An uncharacteristically serious beer jacket design for the class of 1941 (right; this design was repeated for reunions) foretold the challenges facing their class and other Princeton students, faculty, and staff. World War II brought great changes to the campus, which opened to a variety of training programs and sped up graduation with year-round classes. The war finally broke the racial barrier, bringing a few Black undergraduates to campus. They were the first Black students to attend classes at Princeton since James McCosh welcomed their predecessors. While many faculty members and staff joined the armed forces, others played critical roles in research programs, such as the Manhattan Project. Their commitment and sacrifice are poignantly documented on the service flag (below) over the entrance to Nassau Hall, which records 9,669 serving and 329 (later amended to 355) having lost their lives in the war against fascism. (Both, PUA.)

HAPPY BIRTHDAY, TIGER. The fourth-oldest American college celebrated its 200th birthday in style. How liberating it must have felt to celebrate after the grim years of Depression and war! A yearlong celebration attracted many of the world's intellectual and political leaders, 37 of whom received honorary degrees. On June 17, 1947, the closing celebration began with a procession of 1,000 representatives of American and foreign universities to Nassau Hall, led by delegates of the medieval universities. Princeton president Harold Dodds observed that the gathering offered living proof that scholars constitute an international community. Pres. Harry S. Truman, the only 20th-century president without a baccalaureate degree, addressed a crowd of 6,500 on the front lawn of Nassau Hall about the importance of the educated entering public service. Former president Herbert Hoover and future president Dwight D. Eisenhower were also in attendance. Ten years later, Nassau Hall completed two centuries as the university's front to the world. (Both, PUA.)

Seven

THE LONG FIFTIES

Princeton began the postwar period by celebrating the college's bicentennial in 1946. After a decade and a half of economic depression and war, the university was ready for a feel-good event. A year of symposia, lectures, and concerts concluded with the 1947 commencement address by Pres. Harry S. Truman. Former president Herbert Hoover and future president Dwight D. Eisenhower marched with Truman to Nassau Hall to celebrate Princeton's milestone.

Student life soon essentially reverted to its prewar nature. Two undefeated football teams and a Heisman Trophy winner gave the university a particular sparkle. The postwar period ended with another undefeated team in 1964. The clubs were in their heyday, though their reputations were sullied by late 1950s accusations of anti-Semitism. Almost all students were of European ancestry.

Serious students finally got a library worthy of a world-leading research university with the construction of the Harvey S. Firestone Memorial Library, which was considered to be the final gasp of Collegiate Gothic architecture on the campus. Seniors had carrels in which to isolate themselves from distractions and produce their senior theses—a Princeton hallmark and one recalled by many alumni as the most valuable experience of their undergraduate years. For physical well-being, Dillon Gym was constructed on the site of the old gym that had been damaged by fire during the war.

The university continued to reflect academic excellence in many areas. The Institute for Advanced Study (IAS) had moved from Fine Hall, but Albert Einstein continued to walk across campus, and university and IAS faculty members continued to spark off each other as IAS expanded into the social sciences and humanities. Most notable was their role in creating the first electronic computer, an effort led by John von Neumann, one of many faculty members who had fled European fascism.

Although student life settled into patterns seen as traditional, the relationship of the university to the federal government had permanently changed. The outcome of World War II had depended on technological superiority, and Princeton had contributed considerable expertise. Einstein's letter to Pres. Franklin Roosevelt warning of a Nazi nuclear program was the initial contribution. Hidden by secrecy, many faculty members performed essential research in Los Alamos and elsewhere. What President Eisenhower, in a draft of his famous farewell address, called the "military-industrial-university complex" captured that change. Research universities increasingly chased government and foundation support. With the United States emerging from World War II as the greatest power in modern history, Princeton's informal motto—"Princeton in the nation's service"—took on a more urgent, and sometimes troubling, meaning.

HOME SWEET HOME. Returning GIs posed a new challenge—housing married students. Traditional undergraduate monasticism was not appropriate for them or for the growing number of graduate students and young faculty. The response was the Butler Tract, which, although it was labeled temporary, housed students well into the 21st century. Although the accommodation looks primitive to modern eyes, the participants in an oral history (which can be reviewed at findingaids.princeton.edu/catalog/AC259_c58) expressed almost unanimous nostalgia for the years spent there. Veterans still felt the international reverberations of World War II, as shown in this picture of them gathering clothes for war-ravaged Europe. The GI Bill and delayed enrollments put pressure on colleges across the country. Princeton's prewar enrollment of around 2,400 swelled to over 3,400 after the war. However, while many colleges continued expanding, the Princeton administration decided to settle on 2,800 undergraduates and 500 graduate students. (Both, PUA.)

THE UNIVERSITY ENGINE ROOM. For a generation, Princeton had desperately needed a library befitting its ambitions as a research university. Pyne Library, attached to the earlier Chancellor Green Library, had been expected to satisfy this need for a century. Instead, it was outmoded by the 1920s, and the Depression followed by war delayed a replacement for two decades. A committee representing 15 colleges helped plan a structure with innovations borrowed from others, but the exterior followed the Collegiate Gothic tradition. The books were mainly below ground, leaving an open main floor. Great pride was taken in continuing the tradition begun in the Chancellor Green Library in the 1870s of student access to books, resulting in the Harvey S. Firestone Memorial Library becoming the largest open-stack library in the world. Princeton's specialty, the senior thesis, received accommodation in the form of 500 carrels where numerous students labored over their magnum opuses. (Above, DPL; below, PUA.)

LIBERAL EDUCATION REDUX. The horror of World War II generated brainstorming to shape curricula that would prepare students for more peaceful times. The leader in this self-examination was Harvard's *General Education in a Free Society,* which argued for a more structured curriculum, especially in the underclass years. It stressed immersing students in the best of Western civilization while avoiding excessive specialization. Princeton participated in that trend, creating broad courses intended to introduce students to four main areas of knowledge. These distribution requirements remained in place into the 1990s. At Princeton, preceptors remained the essential vehicle to convey the lessons. The U-Store, a member-owned co-op, supplied the all-important books and other essentials of campus life. Engineering was the outlier pedagogically with a more instrumental orientation and physically with the completion of the Engineering Quadrangle in 1962. (Both, PUA.)

PROFESSORS, ABSENTMINDED AND OTHERWISE. The faculty continued to meet in Nassau Hall amidst portraits of Princeton's past. Above, Princeton president Harold Dodds presides over the 1956 meeting celebrating the venerable building's 200th birthday. Although earlier faculty meetings had disciplined students and assigned class rank, the regulation of student life now fell to student-affairs professionals. Faculty members increasingly sought to be spared such duties in order to invest their time in teaching and research. That division was stressful, as Princeton faculty members were expected to keep their departments among the national research leaders while they fulfilled more demanding teaching loads than expected at most research universities. The faculty included many successful pedagogues, none more dramatic than chemistry professor Hubert Alyea, who was reputedly the prototype for the protagonist of Disney's *The Absent-Minded Professor.* On the other hand, some faculty now worked away from the campus at the Forrestal Research Center on Route 1. (Both, PUA.)

IN EINSTEIN'S SHADOW. Princeton continued be an intellectual powerhouse, especially in mathematics and physics, continuing the 1930s tradition of combining the brainpower of the Institute for Advanced Study (IAS) and the university. Among the many stars were the two pictured. John von Neumann (right) played a major role in the Manhattan Project and is credited with creating the first electronic computer. After directing the Manhattan Project, Robert Oppenheimer (left) became the third director of IAS and held that position from 1947 to 1966. (PUA.)

CLUBBABLE. After World War II, selective eating clubs resumed their roles, providing meals and leisurely camaraderie for invited upperclassmen. A 1950 revolt led to guaranteeing club membership to all who applied, seemingly ending the exclusion that inspired Woodrow Wilson's Quad Plan. But exclusion returned in 1958, when 28 were left out. That half were Jewish sparked a public furor prompting a return to offering membership in a club to all. A club alternative, appropriately named Woodrow Wilson College, opened in 1961. (PUA.)

RELIGION'S CHANGING FACE. Princeton had ceased being entirely Protestant before World War I. After World War II, Catholics and Jews were plentiful in the student body, and leading Catholic theologian Jacques Maritain was on the faculty. In 1955, Rev. Ernest Gordon, a charismatic survivor of Japanese POW camps, became dean of the chapel. Although he was a Scottish Presbyterian, he oversaw the end of compulsory chapel attendance and encouraged the use of the chapel by various religious groups. Above, Gordon is speaking to Robert Goheen, the last Princeton president to hold that office based on the 226-year tradition that presidents either be Presbyterian ministers or sons thereof. In 1960, Gordon invited Dr. Martin Luther King Jr. to speak at chapel. In the image at right, King is being escorted to the chapel to deliver the Sunday sermon. It may be hard to imagine today, but the invitation was strongly criticized at the time. Undeterred, Gordon invited Dr. King back in 1962. (Both, PUA.)

ATHLETIC GLORY. After the old gymnasium burned down in 1944, another Collegiate Gothic structure soon arose on the same site with the addition of a six-lane swimming pool. Dillon Gym was the site of the basketball heroics of Bill Bradley ('65), who led the 1965 team to the Final Four. Following the completion of Jadwin Gymnasium in 1969, Dillon became the center for intramural sports and other informal activities. (PUA.)

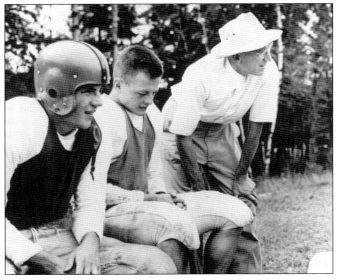

RESTRAINED ATHLETIC GLORY. The postwar period saw numerous sellout crowds at Palmer Stadium. The 1950 and 1951 undefeated teams starred Dick Kazmaier ('52), winner of the Heisman Trophy. This picture captures two legends at the Blairstown training camp—Kazmaier (left) and pioneering sports physician Dr. Harry McPhee (right). The mid-1950s formation of the Ivy League led to restrictions protecting those schools' athletes from the excesses accompanying the dramatic growth of big-time college athletics. (PUA.)

CAPPED AND GOWNED. On the Sunday before graduation, a baccalaureate service in the chapel connects departing students to Princeton's spiritual past. Then, in the historic setting of the Nassau Hall campus, students gather for the last time. Since 1760, the salutatorian has given a Latin address to which the graduates, using crib sheets, pretend to respond appropriately. Rather than having an invited speaker, a bevy of honorary degrees are awarded accompanied by elaborate encomia before the ceremony ends with the president's farewell words of wisdom. (PUA.)

LIFELONG TIGERS. For many, graduation does not the end their connection to the campus. Post-commencement gatherings of alumni had been growing since the Civil War. After World War II, provision for class headquarters and dormitory beds became standard. The Gothic quadrangles were well suited for each major reunion class to call home for a weekend of nostalgia. Panels of alumni speaking in their areas of expertise adds an intellectual dimension to the reunions. (PUA.)

BEFORE THE STORM. When Princeton president Robert Goheen invited Pres. Lyndon Johnson to speak at the dedication of the new home of the Woodrow Wilson School of International Affairs in May 1966, he could hardly have imagined that Johnson's appearance would spark the beginning of political activism on the campus that would have far-reaching effects over the coming decade. But at the time, for many, the larger issue was the architectural departure represented by the architect Minoru Yamasaki's daring design. (Both, PUA.)

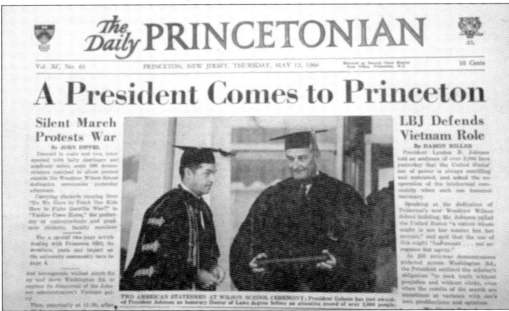

Eight

THE SHORT SIXTIES

The biggest cultural and social earthquake of the mid-20th century truly took place in the last half of the 1960s and lost steam by the early 1970s. It was a time when the verities of the two post–World War II decades—about the Cold War, race, family, gender, sexuality, and corporate capitalism—were challenged and modified or even revolutionized. Youth were seen as the vanguard of change and were at first heralded and then lamented by many.

The herald of change arrived on the campus on May 11, 1966, in the form of that force of nature, Pres. Lyndon Johnson. The civil rights movement had stirred support for Martin Luther King Jr. and the push for change he led. A few brave Princeton students had gone South to join the movement, but most students still viewed the federal government as an ally. That changed with the Vietnam War.

The questionable justification and execution of the Vietnam War and the ongoing social clash it fomented generated deep cultural soul-searching. As support for President Johnson's policies eroded on campuses, divisions emerged. Protests at Princeton grew more uncompromising. Walter Hickel, a member of Nixon's cabinet, faced virulent opposition from some who interrupted his speech but a petition of apology from others.

Other shifts were nurtured in the growing alienation from cultural norms. The most obvious was external—longer hair and more colorful clothing. Cultural standards surrounding sexuality and gender shifted dramatically. For instance, the restrictions on sexual activities in Princeton's dorms were revoked.

In 1969, after over two centuries, Princeton's student body ceased being all men. Student support for allowing women undergraduates to enroll led university president Robert Goheen and the trustees to study—and ultimately approve—gender integration. In the early 1970s, a growing minority of women began sharing classrooms with men and integrating organizations or forming their own.

Religious identity dominated postwar campus controversy until the civil rights movement made race the central campus issue. In the mid-1960s, President Goheen committed Princeton to greater representation of African Americans. In turn, the presence of Black students led to pressures for curricular changes and social provisions such as the Third World Center.

By the early 1970s, social activism had receded, and traditional academic pursuits, although they were never gone, regained prominence.

Finally, architecture provided to be a tangible change on campus. The Yamasaki building that President Johnson dedicated was just the most dramatic statement of the university's shift from Gothic to various modernistic styles.

MODERNISM STRIKES BACK. Firestone Library and Dillon Gym were assumed to be the last Gothic buildings on campus. The stonemasons' advancing age as well as changing tastes doomed what had been the official campus style since the 1890s. The early years of Pres. Robert Goheen saw a succession of buildings that eschewed Gothic style but were architecturally unexceptional and were often concrete and brick shoeboxes, including Corwin Hall, which stood prominently on the corner of Prospect Street and Washington Road. The building that instigated a visit from Pres. Lyndon Johnson was a daring departure. First, Corwin Hall had to be moved—all seven million pounds of it. In its place, Minoru Yamasaki designed a modernistic version of a Greek temple (quickly dubbed "God's bicycle rack" by students) for the Woodrow Wilson School of International Affairs, which faced a reflecting pool that became a summertime oasis. (Both, PUA.)

THE MATHEMATICAL TRADITION. By the 1960s, the Department of Mathematics had outgrown Fine Hall, appropriately named for Henry Fine, the dean who built the department that became home to Albert Einstein and an international leader in mathematical physics. In a dramatic departure, the university proposed a building of unprecedented height near Palmer Stadium. It elicited opposition, and true to the spirit of the 1960s, the Students for Architectural Responsibility briefly obstructed construction. When the structure was completed, Fine's name was added to adorn the 3-story building and its 10-story tower. Continuing the tradition of physically linking physics and mathematics (as with Palmer and Fine Halls), the new Fine Hall sits adjacent to Jadwin Hall, home of the Department of Physics. The departments share a library, appropriately overseen by Einstein. As few on campus know about Fine's impact on the university, it can be said that Fine overlooks the campus, and the campus overlooks him. (Both, PUA.)

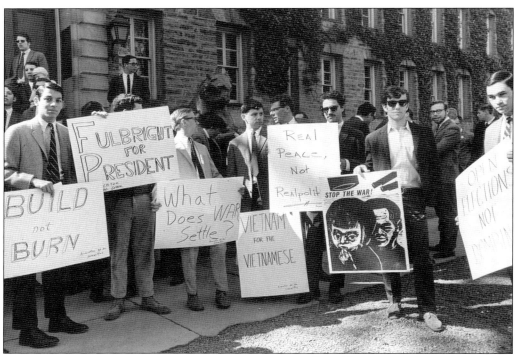

MARCH on the I.D.A.

MAY 6 NOON FIRESTONE PLAZA

WE DEMAND:

AN END to the suicidal arms race.

MORE MONEY for human needs—NONE for nuclear weapons.

NO MORE military or strategic research done by I.D.A. personnel or Princeton University faculty.

ALL research and consultation performed by the I.D.A. or Princeton University be subject to public scrutiny.

WHY THE INSTITUTE FOR DEFENSE ANALYSES?

IDA research is directed in several areas: global nuclear strategy, counter-insurgency planning (currently in use in El Salvador), missile guidance systems, weapons development and other military needs.

IDA research at Princeton is crucial to the network of codes and communications that direct the entire U.S. nuclear weapons complex: WITHOUT IT, THE ARMS RACE COULD NOT TAKE PLACE.

JOIN US

The march will start on campus at Firestone Plaza at 12:00-noon, and from there go down through Palmer Square, back up Witherspoon Str. and left onto Nassau St. Going down Nassau St., we will turn left onto Harrison St. and then left onto Tarhune Rd. The IDA is located north of the Princeton Shopping Center. After the march, there will be civil disobedience, and anyone who wishes to participate should call 921-1136 for more information.

EVEN PRINCETON. Protest came slowly to Princeton, which was initially seen as a conservative Ivy League campus. That changed after Pres. Lyndon Johnson's visit as opposition grew against the Vietnam War, led by the Students for a Democratic Society. In 1968, over 1,000 gathered in front of Nassau Hall to protest the war, with many student wearing neckties. Decorum later broke down when protesters disrupted a talk by Secretary of the Interior Walter Hickel. Busloads participated in the November 1969 March on Washington, with one group famously carrying an "Even Princeton" banner. The April 1970 invasion of Cambodia further galvanized opinions. Meetings of up to 4,000 took place in the chapel and Jadwin Gymnasium, which led to a decision to go on strike. The Institute for Defense Analysis (left, under post–Kent State siege in 1970) and ROTC provided targets for anger and alternative views. (Both, PUA.)

FINALLY, BLACK STRIPES. The number of Black students rose from merely 12 in 1964 to over 300 by 1970. Resulting political sensibilities were demonstrated by the Association of Black Collegians' occupation of New South in 1969 to demand disinvestment in apartheid South Africa. Changing the demographics of the faculty and administrative staff came more slowly, reflecting long-term career patterns and staffing needs. The arrival of Carl Fields as assistant director of student aid was a watershed moment. (PUA.)

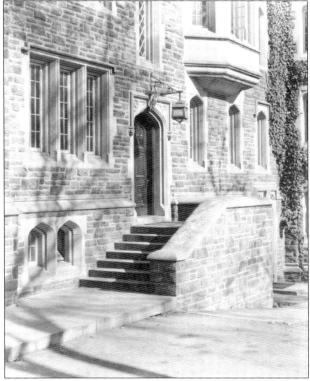

FAREWELL TO *IN LOCO PARENTIS.* Attitudes toward sexuality changed rapidly thanks to dependable birth control and new mores. For decades, those who flaunted the rules risked suspension. A picture of a woman coming down the ladder during a nighttime fire at Patton Hall in 1968 outraged some alumni. A resulting crackdown led to a direct challenge, with hundreds of women openly spending the night. The university ceased enforcement, and two years later, the trustees formally abolished parietals. (PUA.)

COEDUCATION. In 1961, Princeton, the only American research university still not enrolling female graduate students, admitted Sabra Meservey into the Oriental studies doctoral program. Two years later, undergraduate women were admitted for a year-long study of critical languages at advanced levels not available at their home institutions. In January 1969, the trustees voted by a three-to-one majority to admit 1,000 women as undergraduates. WPRB responded by playing the *Hallelujah* chorus. In September 1969, the first coeds arrived, safely closeted in a guarded Pyne Hall. Soon, women were in dorms spread across campus and playing important roles in campus life, even including adding females in the Triangle Club kickline. Coeds also thrived academically; the 1975 valedictorian and salutatorian were both female. That same year, 14 intercollegiate female athletic teams were defending the honor of the orange and black. (Both, PUA.)

WELCOME GATES. Constructed in 1905 along Nassau Street as the main entrance to the campus, FitzRandolph Gate honored a founder who had donated most of the funds and lands that lured the struggling College of New Jersey to Princeton rather than New Brunswick. By tradition, undergraduates and townspeople were forbidden to pass through the formidable gates. In the spirit of the age, the class of 1970 insisted they be permanently opened to welcome all. (PUA.)

DAY OF THE LOCUSTS. The 1970 graduation was unique. Mother Nature contributed by unleashing swarms of 17-year locusts. Most graduates rejected wearing the usual gowns after Pres. Richard Nixon's invasion of Cambodia and the shootings at Kent State ignited nationwide protests. In a gesture to the student counterculture, Princeton awarded singer/poet Bob Dylan an honorary degree. He grumpily accepted and commemorated the day with his song "Day of the Locusts." (*Princeton University Library Chronicle*, Autumn-Winter 2020.)

THE MORE IT CHANGES. Modernity and tradition continuously interact on the Princeton campus. In a concerted attempt to make the campus more aesthetically pleasing in the latter decades of the 20th century, new modernistic sculptures began to decorate the campus. Arguably the most popular—certainly the most photographed—addition was Henry Moore's *Oval with Points*, which was erected on the site of the demolished Reunion Hall in 1971. While abstract sculptures popped up across campus, a distinctly traditional one appeared in the Jadwin Gymnasium lobby. After Daniel French's *The Christian Student* was pulled down by students for the second time in 1931, it was removed to a safe location in Massachusetts. But Bud Wynne ('39), chair of the alumni council's Princetoniana Committee, tracked it down and brought it back to Princeton in 1987. (Above, WBL; left, PUA.)

Nine

BLENDING TRADITION AND CHANGE

Higher education was revolutionized in the late 20th century. Mass higher education, previously a North American phenomenon, spread across the globe in the 1990s. At the top of the food chain were research universities, which had international rankings that were increasingly viewed as indicators of national prestige. Princeton, slow as it had been to embrace the university model at the beginning of the 20th century, was universally recognized as one of the world's leaders at the dawn of the new millennium. It repeatedly ranked near the top nationally and among the top 10 internationally.

However, this success created tension with Princeton's other hallmark, undergraduate teaching and life. Faculty members were increasingly under pressure to contribute to Princeton's standing in the league tables, while alumni and undergraduates had other priorities. Among research universities, Princeton does unusually well merging these pressures, continuing traditions of preceptorials and independent studies leading to a senior thesis. Still, there were compromises. Faculty ceased precepting each other's courses, delegating that role to graduate students. Saturday classes disappeared, and Friday ones became rare.

One attempt to retain social and intellectual coherence was the belated development of a residential college system. Having rejected Woodrow Wilson's Quad Plan and then money from Edward Harkness, the donor who funded the residential colleges at Harvard and Yale, Princeton had missed an opportunity to integrate intellectual life with the social life and left the eating clubs at the center of upper-class life. A variety of alternatives launched in the late 1960s finally led to a full-fledged residential college system by the 1980s, serving all freshmen and sophomores and many juniors and seniors.

A second momentous change was the admission of women, a product of the revolution in attitudes toward gender roles and sexuality. By the mid-1970s, women were a significant part of campus and classroom life at Princeton.

There were other demographic changes. By this time, Catholics and Jews constituted a significant proportion of students in the historically Protestant college. Catholic and Orthodox services were held in the chapel, and a Center for Jewish Life provided kosher dining. Asian enrollment also grew dramatically.

There was also continuity. The clubs survived and began to thrive again. Students still took exams, signed the honor pledge, and wrote theses. Long-standing organizations like the Triangle Club and a cappella singing groups continued, while new student organizations formed around racial, ethnic, and gender identities.

In 1996, Princeton became the fourth American college to celebrate a 250th anniversary, fireworks and all.

WOODROW WILSON'S DREAM COMES TRUE. Princeton diverged from the paths of Harvard and Yale when it declined Edward Harkness's offer to fund Oxbridge-style colleges in the 1920s. Thus, eating/rooming and academics remained separate at Princeton for more than 50 years after the rejection of Woodrow Wilson's Quad Plan and Harkness's largesse. Slowly, options appeared. The first, appropriately named for Wilson, opened in 1968, combining facilities of the somewhat successful New Quad alternative to the clubs. Two years later, the former Princeton Inn became a college that was later named Forbes College (pictured at left). (HSP.)

WU HALL. Needing a coherent plan, Princeton president William Bowen convened the Committee on Undergraduate Life (CURL). In 1979, CURL recommended establishing five colleges to serve all underclass students, combining eating and rooming with social and academic life, with each having a faculty master. Wu Hall anchors Butler College. Since 1986, freshman seminars have strengthened the connection between living and learning. (PUA.)

Gordon Wu Hall.

FEEDING BODY AND MIND. For a half-century after the five Gothic dining halls—collectively called the Commons—opened in 1917, they served virtually all underclassmen. But growing enrollments meant that the five dining halls in the Madison complex beneath Holder Tower (right) could no longer feed all freshmen and sophomores. The overcrowding and growing opposition to the eating clubs required new dining options. The new colleges provided one alternative. Spelman Hall's apartment-style dorm, which opened in 1973 with kitchen facilities, offered another. The Committee on Undergraduate Life recommendation that the university should, in effect, take over the eating clubs generated considerable opposition and was dropped. Some clubs closed or merged, but most, like Cloister Inn (below), survived to continue playing an important social role on the street. About half of the clubs became nonselective, forgoing the ever-controversial bicker. (Both, PUA.)

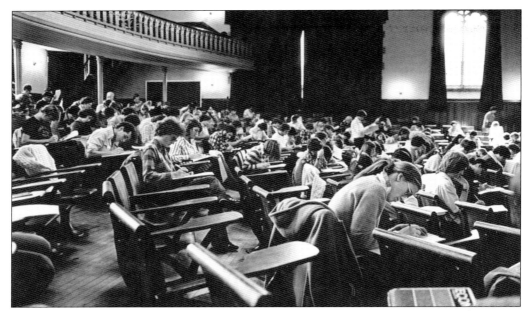

AS INEVITABLE AS DEATH AND TAXES. Although teaching became more experimental, for most courses, some form of exam remained the bedrock evaluation. A tradition since 1893, the honor system remains a deeply engrained part of Princeton culture that has barely changed across the decades except for the coeducation-induced modification of the opening words of the signed oath from "On my honor as a gentleman" to "I pledge my honor." (PUA.)

KNOWLEDGE EXPLODES. With higher education becoming an international priority and leading to new understandings of society and nature, the disciplines around which knowledge had been organized for much of a century were challenged and new areas of knowledge emerged, such as molecular biology. Princeton was slow to recognize the field but later emerged as a leader with the addition of faculty such as future president Shirley Tilghman. (PUA.)

FACULTY STARS. Among Princeton's many prominent recent faculty members, arguably the two best known in the late 20th century were the writer Toni Morrison and the mathematician John Nash, both of whom won Nobel Prizes in the mid-1990s. Morrison's *Beloved* and *Song of Solomon* became classics, and her presence enhanced the creative arts on campus, helping Princeton attract leading writers and poets. Her name continues to resonate on campus, with venerable West College having been renamed Morrison Hall. Nash's fame came in a different way. As a mathematical genius suffering from schizophrenia, his groundbreaking work was intertwined with intense personal struggles. His mathematical genius was finally fully recognized when he became a Nobel laureate, but he came to broader public attention with the movie *A Beautiful Mind* (2001), which depicted his emotional turmoil and, despite the poetic license taken by the filmmakers, broadened public understanding of schizophrenia. (Both, PUA.)

a chicano arts festival

The Arts as a
POLITICAL EXPRESSION

PROGRAM

FRIDAY:		
All day	Arts Exhibition	
5:00 p.m.	Registration	
7:00 p.m.	"Aguada Martinez" *	
7:30 p.m.	Victor Sorrell	
	National Endowment	
	for the Humanities	
	Mexican and Chicano Muralists *	
	*McCormick 101	
SATURDAY:		
All day	Arts Exhibition	

10:15 a.m.	Welcome
10:30 a.m.	Guadalupe Saavedra National Council de La Raza
12:00 noon	Lunch
1:30 p.m.	Socorro Valdez El Teatro Campesino
3:00 p.m.	"No saco nada de la escuela" Acto
4:00 p.m.	East Coast Chicano Student Forum Interplanning Council: Columbia Meetings
5:30 p.m.	Mexican dinner
7:00 p.m.	"Borderlands"
8:30 p.m.	Ballet Folklorico de Aztlan
10:30 p.m.	Party

FEBRUARY 12 - 13, 1982

THIRD WORLD CENTER

Sponsored by: Dean of Student Affairs
Latina Women's Group
Third World Center
Undergraduate Student Government

PRINCETON'S CHANGING FACES. Student demographics changed dramatically in the later decades of the 20th century. The religious makeup at Princeton continued to become more diverse, as shown in the appointment of new chaplains and formation of new clubs. In addition to this, the racial and ethnic composition of the student body also evolved. Asian and Asian American enrollment soared among both undergraduate and graduate students. As in selective colleges across the country, their proportional representation considerably exceeded that of other racial groups. Strikingly, European American students were underrepresented by the end of the 20th century. African American cultural influence grew, and Michelle Robinson (later Obama, '85) remembered "owning" the Third World Center dance floor. New identity-based student organizations flourished, especially those reflecting the rapidly growing Hispanic cultural presence and the increasingly visible gay and lesbian students. (Both, PUA.)

CAMPUS LIFE. Long-standing organizations gave continuity to campus life. Triangle Club celebrated a century of musical comedy, retaining its drag tradition and even parodying its former star, F. Scott Fitzgerald. Music benefitted from coeducation with the emergence of female and mixed a cappella groups. The marching band continued its madcap antics on the football field. Basketball, swimming, and other athletic teams benefitted from Jadwin Gymnasium, dubbed "the house Bill Bradley built." (PUA.)

ATHLETIC TRADITIONS. Athletics reflected continuity and change. Although Princeton was no longer a national power in major sports and protected from competitive excesses by Ivy League constraints, an extraordinary number of Tigers competed in intercollegiate athletics. Many teams, especially women's teams, were of recent origin, but football extended back to 1869. A star of 1950s single-wing teams, Royce Flippin ('56, right), director of athletics, is shown receiving a painting of the original Rutgers–Princeton contest that launched an American obsession. (PUA.)

PRINCETON, 250 YEARS LATER. In 1996, Princeton became only the fourth American college to celebrate a quarter millennium of history. Incredibly, the meeting of a small band of students in Rev. Jonathan Dickinson's rectory in Elizabeth, New Jersey, in 1747 had matured into one of the world's leading universities. The milestone was marked by seminars, presentations (such as this one, with Prof. Paul Muldoon reading a poem written for the occasion), and performances. The

festivities were presided over by Princeton's first president of Jewish heritage, Harold Shapiro. For the historical record, Dan Oberdorfer ('52) wrote an entertaining and attractive history of the quarter millennium, *Princeton University: The First 250 Years*. The celebrations ended with a new tradition of spectacular fireworks over Lake Carnegie. (PUA.)

STILL A CENTER OF CAMPUS LIFE. The world's third-largest collegiate chapel (after King's College, Cambridge, in England and Chapel of the Resurrection at Valparaiso University in Indiana), the Princeton Chapel remains central to campus life. Designed in the 1920s with the intention of reenforcing students' waning Protestant commitment, the chapel now hosts interfaith services and events as well as continuing traditional celebrations such as the Christmas candlelight service. (Thomas M. Swift.)

Ten

CHANGING STRIPES IN A NEW MILLENNIUM

Princeton entered the new millennium with its first female—and first scientist—president. Shirley Tilghman continued the difficult task of combining a nationally top-ranked liberal arts college with an internationally ranked research university. Inevitably, that meant a strain on undergraduate teaching, but arguably, Princeton balances the tension between those two aspirations better than virtually any other leading research university.

The establishment of a residential college system assisted in accomplishing that task. Although Princeton made a questionable decision when it rejected not only Woodrow Wilson's Quad Plan, but also the funding from Edward Harkness that Harvard and Yale accepted, it was now catching up. Princeton had long offered excellent academics, room and board, and social life; now, they could finally be integrated under one roof.

There were noticeable demographic changes on campus too. For much of the 20th century, religious diversity had been the major issue. But by the time of the new millennium, Asians and Asian Americans were proportionally highly represented at Princeton, while other racial and ethnic groups increasingly matched their national representation.

The changing composition spawned new religious and ethnically-based student organizations. The traditional ones also continued—a cappella groups still sang under the arches, Triangle Club still went on the road, and athletic teams still defended the honor of the orange and black. Indeed, Princeton became the first Ivy League college to win 500 championships and in 2018 had the school's first undefeated football team since 1965. And despite the rise of the residential college system, the surviving 11 eating clubs stabilized and then began to thrive. Two-thirds of juniors and seniors join a club, of which five are nonselective and six continue the controversial bicker process.

Although Princeton remains small for a research university, its growth continues, often disorienting returning alumni. Most noticeable is the new arts neighborhood anchored by the venerable but expanded McCarter Theatre. Gothic architecture returned via Whitman Hall. The science neighborhood expanded on the southeast side of campus, bumping up against the successor to Palmer Stadium and other modernized athletic facilities. Next on Pres. Christopher Eisgruber's planning board is expansion beyond Lake Carnegie to create a southern campus.

The future is unknown, but even the past is contested. As William Faulkner noted, "The past is never dead. It's not even past." Alumni, faculty, students, and the administration continue a lively debate over the meaning of Princeton's first 275 years and how that history should be represented on today's campus.

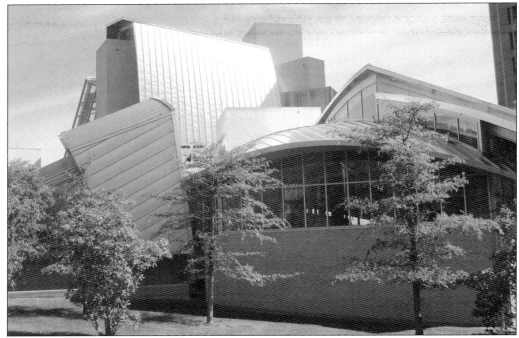

BACK TO THE FUTURE REDUX. Princetonians have been accustomed to architectural surprises since Collegiate Gothic was abandoned as the official style. The resulting campus lacks coherence but provides a walking historical tour of American architecture, encompassing every style from Nassau Hall's Georgian through Romanesque and Collegiate Gothic to International style and various Neos. Frank Gehry's spectacular Lewis Library (above) challenged even hardened fans of innovation. Arguably, the biggest surprise has been Whitman Hall (below), which accomplished what was deemed impossible—a return to Gothic. Alumni who survived the older versions may sniff at air-conditioning and private bathrooms but must envy the creature comforts of Neo-Collegiate Gothic. With Whitman Hall, for the first time, Princeton created a residential quad from scratch for students of all four years in the Oxbridge style. Woodrow Wilson's dream came true a century later. (Both, WBL.)

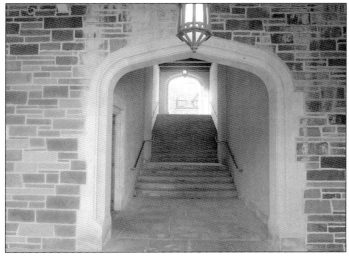

HIGHER LEARNING. A century later, the impressive replica of Oxford's Magdalene College—the location of which doomed the Woodrow Wilson presidency—still loomed over faculty and students. Princeton remained a rarity among universities, as it lacked law, medical, and business schools and had a theological seminary that divorced from the college two centuries earlier. However, this left Princeton nimbler and freer to innovate than most research universities. Despite its relatively small graduate-student body (less than 3,000) and faculty, Princeton continually ranks in the top 10 internationally; Nobel Prizes and other awards keep arriving for the university's alumni and faculty. The nature of the graduate student population also changed demographically. For instance, Tricia Marks (*03, below) celebrates becoming the oldest recipient of a Princeton doctorate in history. (Both, PUA.)

UNDERGRADUATES AT WORK. Princeton students' basic work has not substantially changed and still echoes that of students who took classes nearly a millennium ago at medieval universities. However, the tools have changed dramatically in recent decades. Alumni searching for the catalogue (left) that was once a gateway to knowledge will now find its drawer fronts used as a wall decoration in Firestone Library. Computers are ubiquitous. As they did centuries ago, faculty members lecture much as alumni remember. Princeton's largest lecture room, McCosh 50 (below), was recently renovated with due respect for tradition so that it continues to host courses and panels in recognizable surroundings but with new technology. Audiences can flatter themselves that they are following in the path of Albert Einstein, who delivered his classic rendition of his theory of relativity in this room. (Both, PUA.)

MANY STRIPES. For a millennium, concerns about food, beverages, rooming, exams, and euphemistic social life have been a constant of student activity. At Princeton, connections can be drawn with earlier students across 275 years. However, there have also been significant changes not only in living conditions but in demographics. The entirely European-descended male Protestant College of New Jersey has morphed into an institution that includes different genders, races, ethnicities, and religions. Surely, the founders could not have imagined that one day Sohaib Sultan (at right with his wife, Arshe Ahmed) would become the first—and very popular—Muslim chaplain. The university's alumni contribute to changing Princeton's image and reality, conducting admissions interviews of applicants helping to yield a culturally and racially diverse student body. The Princeton Prize in Race Relations has built an impressive record of promoting racial, religious, and ethnic understanding across the country. (Right, Richard D. Smith; below, Samer Khan.)

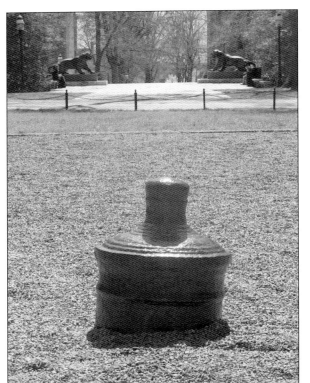

CANNONS, TIGERS, AND "OLD NASSAU." Cannons inspire various Princeton traditions, including a club with that name, the old favorite "Cannon Song," and Cannon Green behind Nassau Hall, the site of Class Days and bonfires since the 1890s. Princeton's Revolutionary War cannon was taken to New Brunswick during the War of 1812, but students—led by Leonard Jerome ('39), grandfather of Winston Churchill—later retrieved it. Once buried, it has not traveled since but is worrisomely sinking. However, stately tigers continue to stand as tall defenders of the orange and black between Whig and Clio Halls. Whatever the changes over the years, gatherings of Princetonians conclude with singing "Old Nassau." In a recent tradition, the football team stops in front of the century-old Tiger Band after home games and leads the crowd in singing the alma mater. (Both, WBL.)

FEARS AND HOPES. The stanza in the Princeton fight song, "The tiger stands defender of the orange and the black," took on new meaning as the university sought to deal with the COVID-19 epidemic. The college had faced polio and influenza epidemics in the past, but none of these forced the virtual shutdown of the entire campus. However unlike during earlier threats, students and faculty could carry on remotely through the wonders of the Internet. Those approaching campus faced a tiger that illustrated the proper length for social distancing. But this too will pass, and future students will learn the "locomotive" cheer and venerable college songs on the steps of Blair Arch in the Freshman Step-Sing. Four years later, with hard work, they will return to the same location to partake in the Senior Step-Sing, a tradition that began in 1760. (Above, WBL; below, Thomas M. Swift.)

TRADITION MEETS MODERNITY AFTER 275 YEARS. One of Princeton's oldest traditions, a Sunday baccalaureate service, connects graduates to the university's spiritual origins. After the interfaith service, which includes the major religious traditions, Presbyterian divine and sixth Princeton president John Witherspoon greets the soon-to-be alumni and their families. Two days later, they gather in front of Nassau Hall for the farewell ceremony—becoming alumni of a university that dates back over 275 years of continuity and change. (WBL.)

BIBLIOGRAPHY

Axtell, James. *The Making of Princeton University: From Woodrow Wilson to the Present.* Princeton, NJ: Princeton University Press, 2006.

———. *Wisdom's Workshop: The Rise of the Modern University.* Princeton, NJ: Princeton University Press, 2016.

Borsch, Frederick H. *Keeping Faith at Princeton.* Princeton, NJ: Princeton University Press, 2012.

Cooper, John M., *Woodrow Wilson: A Biography.* New York: Alfred A. Knopf, 2009.

Geiger, Roger L. *The History of American Higher Education.* 2 Vols. Princeton, NJ: Princeton University Press, 2015.

Inniss, Lolita Buckner. *The Princeton Fugitive Slave: The Trials of James Collins Johnson.* Fordham, NY: Fordham University Press, 2019.

Kusserow, Karl, ed. *Inner Sanctum: Memory and Meaning in Princeton's Faculty Room at Nassau Hall.* Princeton, NJ: Princeton University Art Museum, 2010.

Leitch, Alexander. *A Princeton Companion.* Princeton, NJ: Princeton University Press, 1978.

Leslie, W. Bruce. *Gentlemen and Scholars: College and Community in the "Age of the University."* University Park: Pennsylvania State University Press, 1992.

Maclean, John. *History of the College of New Jersey.* 2 Vols. Philadelphia: J.B. Lippincott, 1877.

Marks, Tricia. *Princeton Luminaries.* Princeton, NJ: Association of Princeton University Alumni, 1996.

Maynard, W. Barksdale. *Princeton: America's Campus.* University Park: Pennsylvania State University Press, 2012

Merritt, J.J., ed. *The Best of PAW: 100 Years of the Princeton Alumni Weekly.* Princeton, NJ: Princeton Alumni Weekly, 2000.

Oberdorfer, Dan. *Princeton University: The First 250 Years.* Princeton, NJ: Princeton University, 1995.

Smith, Richard N. *Princeton University.* Charleston, SC: Arcadia Publishing, 2005.

Thorp, Willard et al. *The Princeton Graduate School: A History.* Princeton, NJ: Princeton University, 2000.

Wertenbaker, Thomas J. *Princeton, 1746–1896.* Princeton, NJ: Princeton University Press, 1946.

DISCOVER THOUSANDS OF LOCAL HISTORY BOOKS
FEATURING MILLIONS OF VINTAGE IMAGES

Arcadia Publishing, the leading local history publisher in the United States, is committed to making history accessible and meaningful through publishing books that celebrate and preserve the heritage of America's people and places.

Find more books like this at
www.arcadiapublishing.com

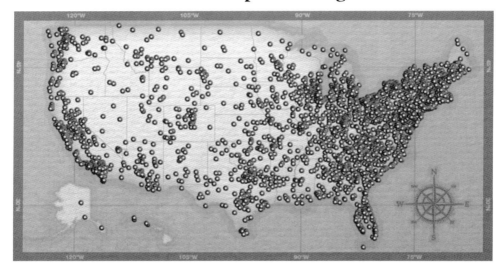

Search for your hometown history, your old stomping grounds, and even your favorite sports team.